Pick up a

PEN

DRAW AND DOODLE WITH
EVERY KIND OF PEN

Frances Moffatt

PORTICO

Contents

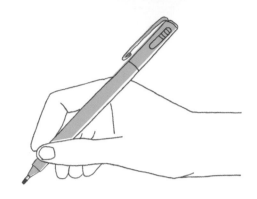

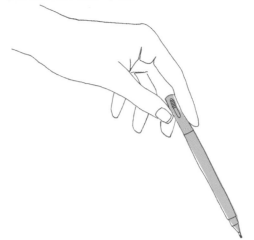

Pure Pendamonium

INTRODUCTION

Look up from this book. Take a peek around the room. How many pens can you see?
I guarantee the answer is more than one. It could even be hundreds if you're like me.

Pens are everywhere and pens are awesome. They are more than just a tool for writing things down, or doodling, or scribbling, or throwing at a friend to get their attention; pens are the purest way to express our feelings, communicate ideas big and small and beat out a rhythm, and are even something to chew and nibble on when we are distracted with those big and small ideas. Yes, pens are great. But just how awesome are they? Well, that's what *Pick up a Pen* is all about.

In this modern world of laptops and smartphones, pencils and pens have been pushed aside by some people, forgotten by others and ignored by many, replaced by keypads and tapping fingers.

And that's fine — this book isn't about bashing technology, we love it far too much to do that. No, this book is about loving pens, for all they can do, and all that they have done to help capture, communicate and record the wandering thoughts of humans down the ages, ever since humankind scratched stones onto cave walls.

So, grab that pen. The one you can see in your eyeline, or your favourite pen. The one that feels really good in your hand — as if it belongs there.

Now, start drawing a line. Who knows where it might lead you?

Enjoy!

Strike a Pose!

DRAW YOUR OWN FASHION MAGAZINE COVER

For years the worlds of art and fashion have long been each other's muses. Today, they are inseparable, joined at the hip and hand. In the mid-1900s, before photographic technology changed everything, famous fashion magazines such as *Vogue* and *Harper's Bazaar* relied on pen-illustrated covers to entice their readers. Today, many of the world's greatest artists have dipped their nibs into the fashion world. So, why shouldn't you?

Pen to Paper

Before we set our nibs to stun, let's first factor how we want our fashion magazine cover to look and feel. What's the title of your magazine? What typeface will your title be in? Do we want to employ colour? What type of pen will you use? What copy or visuals do you want to include? Sketch out your idea first, and then when you're confident with an idea…start inking.

One Step at a Time

1 At the centre of a large piece of coloured or white paper, draw a rectangle. Use a ruler to get precise proportions, or draw freehand if it's your first rough sketch.

2 Most magazine covers have their titles, known as logotypes or mastheads, at the top. This is so they can be seen when stacked in shops. Putting your title anywhere else risks people not being able to see the name of your magazine. Will your drawing overlay the masthead, or vice versa? Think about this in advance. The fashion and style magazine *Cosmopolitan* famously overlays its cover visual over its masthead.

Things to Think About NOW

What logo will you use for your fashion magazine cover? What size will it appear? What other copy will appear on the magazine cover?

INSPIRATION BUTTON

As you sketch or ink, have examples of fashion magazines you wish to use as inspiration next to your pad. This will help you get a sense of what goes where!

3 With your masthead secured at the top of your rectangle, it's time to think about the central image. Most fashion magazines use either a portrait of a face, or a full body. For our example, let's draw a head.

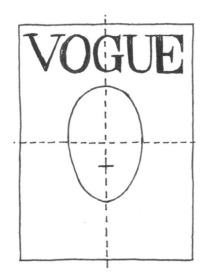

• Draw an oval in the centre of the rectangle. Measure the distance from left to right and place a + at the centre of the page. This is where the nose will go.
• In the middle of the oval, halfway between the top of the head and the chin, draw a horizontal line. This is for the eyes and the top of the ears.
• Draw a vertical line down the centre of the oval, like a cross-hair target, that will line up with your initial +.

• With these basic, but symmetrical, outlines of a human face, you are now free to fill in the face with features, such as eyes, nose, ears, hair and mouth.

4 Now the masthead and face are in place, you can add in words around the face of the other features that will go in your magazine. These are the final touches, but do think in advance what copy goes where, because if you are using ink, you don't want to worry about ruining your awesome cover with a mistake!

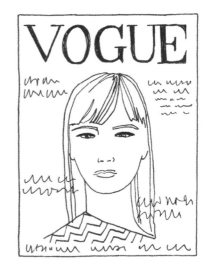

Many famous artists, including Hattie Stewart, Andy Warhol, Shepherd Fairey and Jeff Koons, have designed fashion magazine covers. It was the anatomy-obsessed British conceptual artist Damien Hirst, though, who caused a stir when, in the summer of 2009, he drew the cover of *Tar Magazine* and took the face off supermodel Kate Moss, revealing her interior anatomy. The result was bizarre, but striking. As all good art should be!

Fine Times

HOW TO USE A FINELINER

Everybody knows the pen is mightier than the sword…but only if you hold it correctly. It may sound simple, but holding a pen correctly as you doodle, draft or draw improves your line technique and creates less stress on your digits. So, let's practise with a fineliner pen, an inexpensive and disposable alternative to more expensive technical pens.

STRAIGHT LINES

As their name implies, fineliner pens have a narrow tip, usually less than 0.4mm, making them ideal for inking ultra-fine details in your drawing, sketching and handwriting. Due to their super-strong nibs, fineliners produce a 'hard' line and work better with a bold, confident drawing stroke, rather than shorter, feathered strokes.

INK AWAY

For drawing, look for fineliner tips that have lightfast and waterproof pigment ink to ensure your drawings have longevity.

HOLD ON!

Always hold your pen so it feels comfortable. One of the worst things you can do is to force yourself into using a grip that feels unnatural, or upsets the natural flow of your line. So, experiment with how you hold your pen. This may sound daft, but look at your hand and really focus on how you hold it.

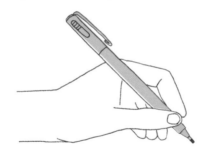

The Classic: Tripod

The most common way artists hold a pen is the classic grip: the Tripod. It is the perfect grip for drawing intricate details. The upright position of the pencil allows for accurate shading with the tip, rather than the side, of the pen. Place your thumb and forefinger around the pencil to form a triangle with the middle finger, which is supported by the ring finger and little finger. For best results, make sure you keep a relaxed grip on the pen — too tight a grip tires the hand and restricts flow. Don't be a pen pusher — caress your pen with a tender touch!

The Extended Tripod Grip

If you want more flow and freedom of movement in your hand — as well to stop smudging ink into the paper — simply move this Tripod hold further up the pen, away from the nib. You'll create a different quality of line if you do.

A MIGHTY FINE PEN

Fineliners are revered by artists who employ stippling (see page 96) and crosshatching (see page 68) techniques.

Stippling

Stippling is the creation of a pattern using small dots to highlight varying degrees of shading.

Crosshatching

Crosshatching is a method of shading by drawing crossing lines that form many small 'X' shapes on your drawing.

INSPIRATION BUTTON
Try mixing up different nib sizes in the same drawing to give your piece a distinct look with diverse edges and tone. Remember, if you use a smaller nib, use a lighter hand.

PEN NIB SIZE

Fineliner pen nibs come in many shapes and sizes. Some can go as low as 0.1mm — the thickness of a human hair! These sizes indicate the width of the line that this pen will create. Here are three drawings using three different pen nib sizes:

Recommended fineliner brands
- Mitsubishi Uni Pin
- Kuretake ZIG
- Faber Castell
- Pilot DR
- Staedtler Pigment Liner
- Schneider Xpress (a lovely premium fineliner)

0.5mm
(very fine)

0.8mm
(medium line)

1.0mm
(thick line)

Meet Andy Warhol!

Andy Warhol's art defined the look of the 1960s. As the founder of the Pop Art scene, the pioneer who coined the phrase 'famous for 15 minutes' and the visionary who invented mass-market art, to say Warhol was a creative genius is an understatement. He was also pretty nifty with a pen. And it was with that humble instrument that he first made his mark on the world…

TOP TEN FACTS

What do we know about Andy Warhol? Here are ten facts about the global pop art icon.

1 With his self-penned blotted-line technique, the American artist transformed everyday items into creative art and figured out a way to mass-produce his artwork.

2 In 1955, Andy was commissioned to produce weekly adverts for shoe brand I. Miller to run in the *New York Times*. The adverts ran with witty slogans written by Warhol's mum, Julia Warhola, in distinctive handwriting.

3 Warhol's iconic 'blotted-line' technique was the hand-drawn precursor to what we now see in the fashion industry as silk screening, the process by which any image can be reproduced on an item of clothing.

4 Warhol worked as a draughtsman through his use of graphite, ink, dye, gouache and collage. Foreshadowing his mastery of form and content, these early works are imbued with Warhol's later concerns as a Pop Artist, both conceptually and formally. This survey shows that they were a part of his practice well before the soup cans made their debut in 1962.

> 'I am a camera.'

5 Andy Warhol was born Andrew Warhola on 6 August 1928, Pittsburgh, PA, USA.

6 As a teenager, Warhol went to the Carnegie Institute of Technology, where he studied Pictorial Design.

7 After graduating in 1949, Warhol moved to New York City and found work as a commercial illustrator for the fashion magazines *Vogue*, *Glamour* and *Harper's Bazaar*.

8 His first exhibition was in 1952 at Hugo Gallery, where he exhibited drawings based on the writings of author Truman Capote.

9 Warhol's iconic Campbell's soup can paintings were first exhibited at the Ferus Gallery, Los Angeles, in 1962, propelling him to fame as the pioneer of the Pop Art movement.

> 'Art is what you can get away with.'

10 Warhol remained one of the major artists of the 20th century. His art can be found in museums all over the world, including the Metropolitan Museum of Art, New York and the Tate Modern, London.

> 'An artist is someone who produces things that people don't need to have but that he – for some reason – thinks it would be a good idea to give them.'
>
> Andy Warhol

DRAW LIKE WARHOL

Want to draw like Warhol? The artist's blotted-line technique defines his style. In essence, it is a form of printmaking. Here are some other Warhol-inspired images.

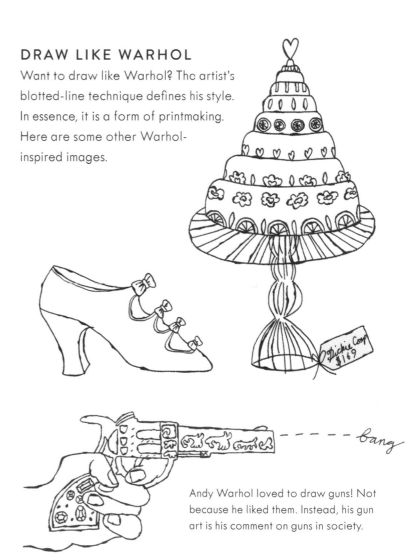

Andy Warhol loved to draw guns! Not because he liked them. Instead, his gun art is his comment on guns in society.

Deeply Dippy

HOW TO USE A DIP PEN

An elegant way to express yourself with a flourish, a dip pen shows to the world you have style *and* panache. Perhaps the hardest pen type to perfect, in terms of technique it can be frustrating to master, but very rewarding for those who stick with it. The invention of the dip pen parallels the era of the Industrial Revolution. It was a modern pen for a modern age!

The dip pen became the newest writing trend in the early 19th century, replacing the trusty (but old-school) quill, after a millennium of it being the champion of writing instruments, as the go-to way of making a point.

What is a Dip Pen?

A dip pen consists of two parts: a metal point known as a 'nib', from where the ink flows, and a handle. Once upon a time, the nib was made of copper and bronze. Today, it is made of steel. A dip pen works by using gravity and capillary action (see page 25). It doesn't have its own reservoir — the name given to the part of the pen which contains the ink — so has to be dipped in an ink bottle or inkwell. Hence the name!

How to Use a Dip Pen

Let's keep this simple.

1 Hold a dip pen like a regular pen, but don't use it like a regular pen. In order to master your writing technique, you must vary the pressure you are putting on the nib. For downstrokes — press hard. For upstrokes — let the pen kiss the paper gently. This stops the ink from getting messy.

2 When you dip your nib in the ink, make sure you dip the nib just past the well 'hole' in the pen.

3 Place the nib on the paper immediately after dipping it in ink. Very important!

4 To ensure a smooth flow of ink, wipe and clean your nib every minute or so.

DEEP DIVE INTO DIP PENS — FOUR FACTS

1 Dip pens transformed the world of writing by replacing feather quills with metal nibs, which allowed ink to flow better onto paper.

2 It was John Mitchell of Birmingham, England, who was the first to mass-produce steel pen nibs in 1822, and it was in his factories that the metal pen industry was perfected. He had 13 principal factories employing 80 per cent women to manufacture pen nibs for the whole world. The power of the machine age, and metal pens, helped solve illiteracy. By 1860, half of all dip pens in the world were made in Birmingham, where there were now thousands of dip pen factories.

3 Dip pens were considered better than quills — they lasted longer and were built on a production line in factories, so you didn't have to pluck a goose every day, and they didn't need sharpening.

4 Dip pens are great for artists and writers. They can deliver thin and thick strokes, depending on the pressure from downstrokes on the surface.

Pens Through the Ages

A HISTORY

When you think of pens, what springs to mind? A biro? A quill? A fountain pen? For several millennia, at least, humans have been scribbling things down. Let's zoom through space and time and take a look at the pens that have made history…

1 Around 4000BC, in the ancient city of Babylon (in what is now Iraq), mankind first scratched the surface of pen technology by inscribing a moist clay tablet with a bronze or bone tool. It was called a 'stylus'.

2 Around 3000BC the Ancient Egyptians developed hieroglyphics, a language that uses pictures as words. They wrote on papyrus scrolls and used reed straws to write with black ink made of soot, ash or red ochre, mixed with vegetable gum and beeswax. The plentiful reeds growing in the delta of the Nile supplied both scrolls and straws.

3 Around 1300BC those crafty Romans began developing their own way of writing: using a metal stylus on sheets of wax on wooden tablets.

4 The Dead Sea Scrolls, which were produced some time around 100BC in the Qumran Caves in (now) the West Bank in Israel, were written with quills.

5 The earliest ink brush, found completely intact, was discovered in the tomb of a Chu citizen in China in 1954. It dates from 475–221BC, an era known as the 'Warring States' period of Ancient Chinese history.

6 Around AD600–1800 it was the Europeans that transformed writing and pen technology — they wrote on parchment with a quill pen. Their rudimentary understanding of words meant they wrote only in capital letters for many decades! Invented in Seville, Spain, quill pens were the dominant writing tool for more than 1,200 years!

7 In 1803 the metal pen was patented, replacing quill pens.

8 1888–1916: It was around this time that the ballpoint pen first originated, but it didn't take off.

9 In October 1945 the ballpoint pen was introduced to the world as 'the first pen to write underwater'.

10 It was in 1953 that disposable (and cheap!) ballpoint pens became available when Marcel Bich invented the industrial process for manufacturing ballpoint pens.

11 The 1960s saw the invention of the felt-tip pen, by the Tokyo Stationery Company in Japan.

12 The rollerball rolled into life in the 1980s.

13 Pens finally got a grip, a rubber one, in the 1990s.

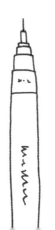

Take a Line for a Walk!

CONTINUOUS LINE DRAWING

What is a line? Think about it. It is the journey of your pen from one point to another. In your sketches, lines are everything. Without them you wouldn't be able to get from A to B. Lines can be straight, short, long, thick, thin, smooth, textured, broken, flowing, erratic, dark, light, heavy, soft, hard, playful, smudged, uneven, crooked — their potential is limitless. So, let's take a line for a walk…and see where we get to.

No Lifting!
With continuous line drawing you're not allowed to lift up your pen from the page. If you need to get back to a starting point on your sketch, you must only move your pen across the surface of the paper and either draw over a line, or create a new one. No broken lines allowed!

Hand-eye Coordination
Practising continuous line drawings will help you develop speed and encourage your eyes, hand and brain to work together as you sketch.

DRAW A BATH
Here's a quick little exercise for you.

1 Think of a bath. Visualize it in your mind.

2 Draw the outline of a bath — using only one long and unbroken line.

3 Now, draw these things: a face, glasses and a rose. Pay attention to not breaking the line as you go from one point to another.

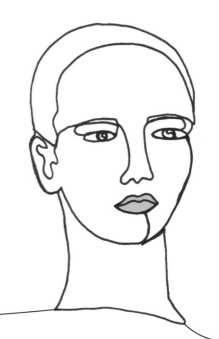

Blind Contour Drawing

Take your continuous line drawing a step further and practise blind contour drawing. Draw a the outline, or contour, of a pair of trainers. But, most importantly, don't look at the piece of paper as you sketch. Keep your eyes focused on the shoes! This technique will strengthen the coordination between eyes, hand and brain. Remember, drawing is all about what you see, not what you sketch!

Using your pen, vary the line weight of each line in your sketch. This will highlight perspective and areas of light and shadow. Thick lines for shade. Thin lines for light.

4 Remember, no lifting your pen up from the page!

Picasso's famous dog line drawing uses this technique (see page 31).

Reed All About it

THE REED PEN

Before the reed pen, writing on clay tablets was an uncomfortable and frustrating experience. With the invention of pigment for ink, and the bright spark who thought of using reeds, a tall grass found along rivers, all of a sudden writing was about to get a jolt of innovation that would make a permanent mark on the world.

In its earliest days, for centuries, writing was fairly laborious. It involved carving pictures into non-portable, and brittle, clay surfaces. As we all know, the Ancient Egyptians were a clever bunch, so they developed a better way of writing. They used a type of hard grass. And for more than 1,000 years, everyone wrote with it.

A reed pen is made from a single piece of reed. The reed is cut to a point and then split at the end. The Ancient Egyptians would then dip the reed pen into an ink. It was a particularly messy way to write, and after a short time the reeds would lose their sharp points and have to be replaced.

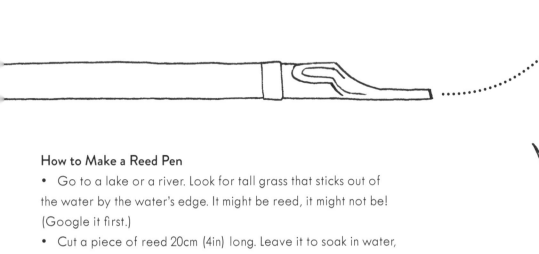

How to Make a Reed Pen

• Go to a lake or a river. Look for tall grass that sticks out of the water by the water's edge. It might be reed, it might not be! (Google it first.)

• Cut a piece of reed 20cm (4in) long. Leave it to soak in water, to avoid splinters.

• Make a series of cuts so the pointy end is nice and pointy. Then chop off the pointy bit, leaving a square end.

• Now, split that in two, very gently, leaving an incision of only a few millimetres. Dip this in ink and see if it works!

Meet Edward Gorey!

The American pen-and-ink illustrator and author who put playfully grim and gory details into all his drawings was also revered for his prodigious, original and offbeat humour, brilliantly showcased in his most renowned works, *The Gashlycrumb Tinies* and *The Wuggly Ump*, both published in 1963. Ladies and gentlemen — it's Edward Gorey!

TOP TEN FACTS

1 Gorey published more than 100 books. His most acclaimed are *The Gashlycrumb Tinies*, *The Doubtful Guest* and *The Wuggly Ump*.

2 Gorey's illustrations have appeared in many books by prestigious authors, including Charles Dickens, Edward Lear, Samuel Beckett, Virginia Woolf and H.G. Wells.

3 Gorey was a drawing prodigy, having learned to draw by the age of 18 months. His earliest illustration was called *The Sausage Train*.

4 *The Gashlycrumb Tinies*, published in 1963, is a darkly comic, or 'very gorey', alphabet book for children of all ages. It combines rhyming couplets with macabre drawings of children who meet their demise in a series of gruesome and grim ways, all playfully illustrated by Gorey. 'A is for Amy who fell down the stairs, B is for Basil assaulted by bears.'

5 Gorey was also an award-winning set and costume designer; the Broadway production of *Dracula* won him a Tony award!

6 Gorey's characteristic pen-and-ink drawings often depict vaguely unsettling narrative scenes in Victorian and Edwardian settings.

'If something doesn't creep into a drawing that you're not prepared for, you might as well not have drawn it.'

Edward Gorey

7 Gorey published much of his work under a collection of humorous anagrammatic pen names including Ogdred Weary, Dogear Wryde and Ms Regera Dowdy.

8 Gorey's experimentation with his books was famous. He created books that were the size of matchboxes and books that had no words!

9 Gorey described his work as 'literary nonsense', a genre made famous by *Alice in Wonderland* author Lewis Carroll.

10 Gorey's illustrations were made with many, many pen-and-ink lines – he didn't paint with a brush or fill in areas completely, he only used a pen and created his art entirely out of tiny lines

'My favorite journey is looking out the window.'
Edward Gorey

GOREY EXERCISE

Gorey always drew from his imagination, not just what his eyes could see. In his honour, let's close our eyes and use our imaginations to draw.

1 Empty your mind. Clear your thoughts. Now…

2 Think of a scene or a creature. Anything.

3 Without hesitating, sketch it down with your pen.

4 What have you drawn?

5 Now, using your pen, start adding some detail with various drawing techniques – crosshatching light and shade, adding value and texture to the drawing.

6 Consider where the light is coming from – a lightbulb? A candle? A window? (Remember your 'X's must be further apart for light areas, closer together for dark.)

As Light as a Feather

THE QUILL

Ah, the quill. Would a pen by any other name sound as sweet? Reed pens may have been the first type of pen, but it was the mighty quill, as light as a feather, that captured the thoughts of how the world was feeling. Made from a wing-feather of a large bird, such as a goose or turkey (or swan, if you're feeling fancy), quills were the pen of choice, first appearing in Seville, Spain, around AD600, before the world went dippy for the metal-nibbed dip pen.

As the pen evolved, so did human civilization. Some of the world's most important historical documents, including the US Declaration of Independence, the US Constitution, the Magna Carta and all of Shakespeare's plays and poems, were written with quill pens.

The word 'pen' comes from the Latin word 'penna', which means feather!

TIP If you want to avoid ink blots, sprinkle sand on your paper!

- Go for a walk. Find a large bird. Befriend it. Ask it if you can borrow one of its wing feathers. If it agrees, great. If not, walk away.
- Once you find an agreeable bird, select your feather. In order to write efficiently, you'll need a feather long enough to hold comfortably. Feel free to trim the feather. You don't need the fur, you just need the spine.
- With a sharp knife (maybe ask a parent) cut the 'nib' of the quill at a 45-degree angle. Dip the quill in ink and away you go.

When you write with a quill, hold the quill at a 45-degree angle.

Let's Talk About Capillary Action

Capillary action occurs when liquid moves through a tube. It is the result of the surface tension of liquids. Think of a sponge in a puddle of water — the sponge absorbs the water, sucking it up and drawing the water into the sponge. That's capillary action in action! And it's how quill pens work.

Facts About Feathers

1 Feathers are perfect for writing — they're hollow and produce a sharp tip that can be flexible.

2 Feathers first evolved on birds around 200 million years ago. Many of the first dinosaurs had feathers, as they are the result of evolution from scales on reptiles. Birds are now the only creatures on Earth to have feathers.

3 Quill pens remained the most popular pen until dip pens, but they are still seen today. Every day, 20 goose quill pens are placed on the tables of the US Supreme Court when it is in session.

4 The common penknife is so called because of its original purpose of cutting and sharpening quills.

How to Draw Fruit

Fruit has long been art's muse. For centuries, famous artists have looked hungrily at fruit, not just for their stomachs, but for their minds too. Want to draw fruit? Here's how.

LIFE IMITATES ART

Capturing still life is one of the biggest challenges that faces any person holding a pen, staring blankly at a piece of paper. How to capture what the eyes see in a way that intrigues the mind?

> *'Treat nature by the cylinder, the sphere and the cone.'*
>
> Paul Cezanne

How to Draw Fruit

1. Begin by deciding what is going to go in your fruit bowl — here we have chosen apples, oranges, bananas and grapes. Now take a pencil and sketch in the basic shapes — circles for the orange and apples, smaller ovals for the grapes, sausage shapes for the bananas, and a trapezoid for the bowl.

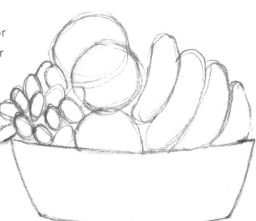

2. Now take a pen and, using the pencil guidelines, draw in the outlines of the fruit and the bowl.

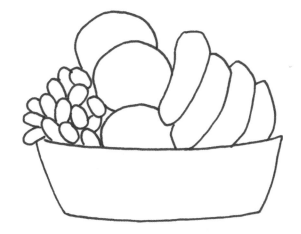

FAMOUS FRUIT

The Basket of Apples, Paul Cézanne, 1895

It was the artist Paul Cézanne who brought the genre of still-life art to life. His painting *The Basket of Apples* is revered for its double perspective. This painting depicts more than just a boring bowl of fruit. Instead, it delves into the finer details of how we see these objects by exploring light, shadow, tone and composition.

3. Now you can add further detail to the fruit — stalks, marks on the skin and shading to give a sense of three dimensions.

4. Now add your final extra details. Why not try drawing a pattern on the bowl and drawing in the table the bowl is on, to give a sense of space and context?

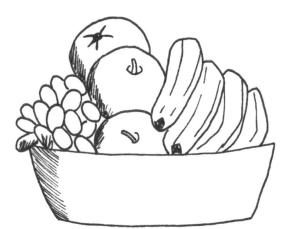

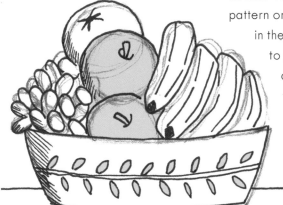

Meet Matisse!

French artist Henri Matisse made simple line drawings look like hard-to-master masterpieces. But his work with a pen was anything but simple. The artist often laboured over these drawings, so desperate was he yearning to achieve 'the art of balance, or purity and serenity' in each and every one.

'Drawing is of the spirit and colour of the senses!'
Henri Matisse

SIX FACTS ABOUT MATISSE

1 Matisse's weapon of choice when it came to his pen-and-ink drawings was a reed pen using carbon black ink, the perfect pen to draw the flowing Arabesque lines for which he was famed.

2 Born in 1869, Henri Matisse became famous in his lifetime for the paintings *The Dinner Table*, *Woman with a Hat*, *The Dessert: Harmony in Red* and *Le Rifain Assis* — check them out!

3 Matisse changed his style a lot. In the 1930s, he created a series of pen-and-ink drawings based on the relationship between the artist and his model, often a nude female. In the 1940s and '50s, his drawings applied thicker outlines, known as contours, and were bolder in attitude.

4 Drawing was an emotional process for Matisse, and he felt that line drawing was the most expressive because it was the purest in terms of the control the artist has.

Look at the line
work of Matisse...
delightful!

5 Matisse would only finish a drawing
when 'it empties me entirely of what I feel'.

6 Matisse was a leader of the Fauvism
(wild beasts) movement that emphasized
the application of non-realistic colour.
Basically, they used really vibrant colours!

Autograph Hunters

FAMOUS SIGNATURES

The signing of your name, or signature, should be as unique and as distinct as you. It should be a squiggle that reflects your personality. For famous artists, signatures are another way of making their mark. Why not create a signature signature for yourself? It's easy...

Create Your Own Signature

1 Find a piece of paper.

2 Grab your trusty pen.

3 Without thinking, write your name down.

4 Do it again, but this time think about what you'd like your signature to be. Go crazy? Or keep it simple? Cursive (joined up) or not?

5 Experiment. Rewrite your signature over and over in several different ways and styles. Which one feels right?

6 Why not emphasize certain letters in your name, or underline it with a flourish?

7 When you come up with a signature that feels right, take a look at it. What does it say about you? Is it flashy and explosive, or is it subtle and refined?

> **Remember:**
> Once you have developed your own signature, it's very hard to change it, especially if you've signed important documents. So, make sure it's a good one!

Damien Hirst first autographed his sharky scribbly signature in 30 seconds in the back of a car. It's now worth loads!

SIGN YOUR NAME

Let's take a look at two contrasting examples of famous artists' signatures: Salvador Dalí and Pablo Picasso. Try signing your name in their style — does it feel right for you?

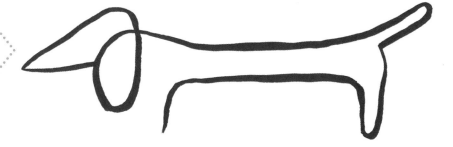

The signature of famous Spanish surrealist Salvador Dalí was a written representation of his nutty personality! Will your signature be like his?

One of the most important artists ever, Picasso, had a much more refined and straightforward signature than Dalí. Only some of the letters are joined up. Is this more your style?

Picasso's dog, drawn as one continuous line drawing, is world-famous.

Try developing your signature in one continuous line. Does that feel right for you?

Drawing in Thin Air

3D PENS

The future is here! And, of course, it's pen-shaped. The 3D pen, or 3Doodler to give it its brand name, arrived in 2013, and its application is beginning to revolutionize digital drawings. The civilisation of the world has evolved in tandem with the evolution of the pen, from reed pens to quill to ballpoints, so it's only natural that a 3D pen has arrived now to reshape the future...

A Pen in Three Dimensions

Invented by Max Bogue and Peter Dilworth in 2013, the 3Doodler became the world's first and (so far) only 3D printing pen. Working on the same principles as 3D printers, the 3D pen allows users to create three-dimensional objects out of thin air — literally!

How Do They work?

Using the plastic material used by many modern 3D printers — ABS or PLA plastic — a 3Doodler draws in the air or on surfaces, and extrudes heated plastic, which cools instantly when it feels the breeze of oxygen and solidifies into a strong structure.

Give it a Go!

With a 3Doodler, you can draw anything that your imagination dreams up…in 3D! For example, try drawing a building, like the Eiffel Tower. Instead of your drawing being flat on the page, it will build up in 3D! You can use many different colours too. All you have to do is load a different colour filament into the pen.

'Remember always that the composer's pen is still mightier than the bow of the violinist; in you lie all the possifilities of the creation of beauty.'

John Philip Sousa

Stay Sharp

NIBS

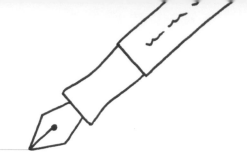

It was with the invention of the nib that the pen truly started to show its potential. No longer was the pen a blunt tool, slapdash, messy and uncivilized. Now it had become refined and elegant. Now, pens could make their point with style…

History of the Nib

A nib is the pointy end of any pen, the part that kisses the paper and introduces the ink to the page. It has been reported that the earliest known copper nib was found in the ruins of Pompeii, Italy, the town destroyed in AD79 by volcanic ash from nearby Vesuvius. However, it wasn't until the late 18th century that dip pens, or 'New invented metal pens!', became common, with a patent issued in 1803.

Metal nibs date back as far as Ancient Egypt, with precious metals like copper and bronze being the most common material, but the world had to wait until 1822 before they became truly popular. Englishman John Mitchell pioneered the mass production of steel nibs; these nibs stayed sharper for longer, and in one swift move completely replaced the quill pen as the dominant writing instrument.

Know Your Nib

Nibs can come in all shapes, sizes and styles, depending on your drawing needs. But generally, the main two types are broad nibs and pointed nibs. Broad nibs have a flat edge, whereas pointed nibs — well, you get the picture. They're pointy!

When writing with a broad nib, different pressures and angles allow the ink to be dispensed differently, creating different scripts, which is important in the art of calligraphy. For pointed nibs, thicker lines are created by exerting more pressure on the downstroke, allowing more ink to rush to the page.

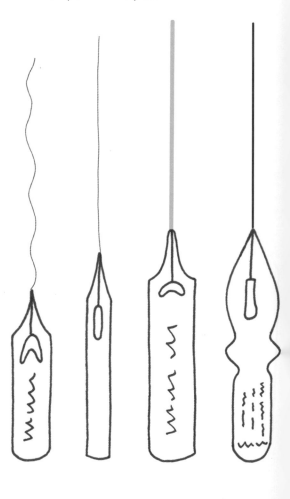

Calligraphy

Calligraphy is the visual art of writing. Or, put simply, writing decorative letters with fancy flourishes! By expertly using the nib of their pen to creative effect, calligraphers can create and design many forms of lettering. An easy way to experiment with calligraphy is by practising your signature (see page 30), but using different pressure on your pen nib to create different thickness of lines for each individual letter.

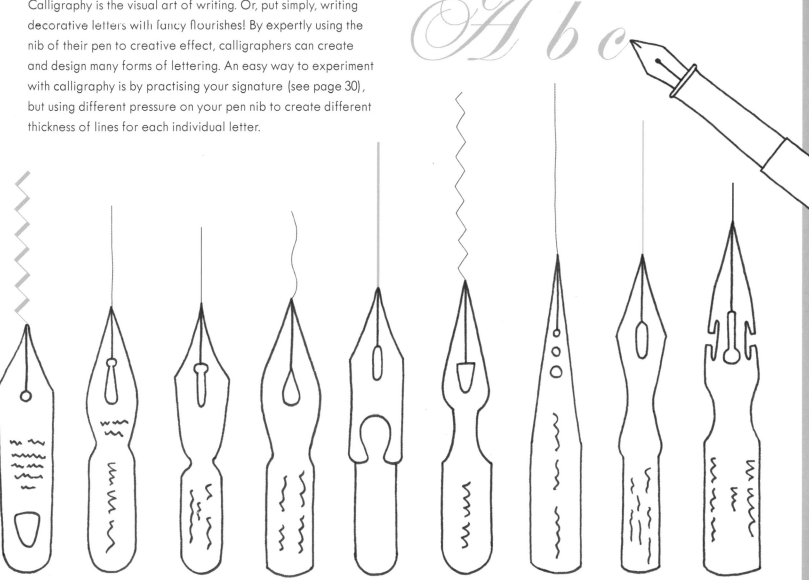

35

How to Draw A Bird

When you reduce anything to its essential characteristics, you'll notice everything, even a human being, is just a collection of shapes merged together. In honour of quill pens, and the many feathers borrowed to make them, let's learn how to draw birds — using Picasso's words of wisdom…

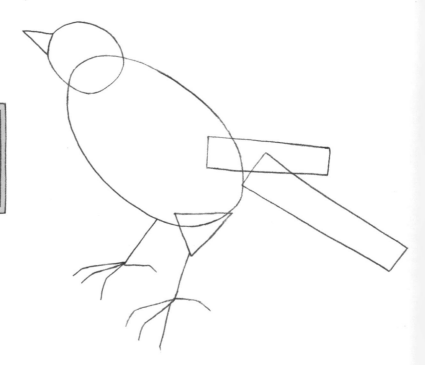

> 'To draw you must close your eyes and sing.'
>
> Pablo Picasso

FLIGHT OF FANCY

Before you fly off the pen handle and start drawing any old bird, stop and think about what type of bird you want to draw. What can you see in your imagination? As Picasso once said, 'What you can imagine is real,' so rather than just draw an ordinary bird, why not give your bird your own particular spin…

But first, let's get the contours down — using basic shapes.

1 With a pencil, draw an oval in the centre of your paper. This is the bird's body.

2 For the bird's tail, draw a rectangle.

3 Above this rectangle, draw another smaller rectangle. This is a wing.

4 For the leg, a triangle will suffice as an outline.

5 Add feet and claws, as shown here!

6 With the basic shapes and contours of the bird in place, flesh out your drawing with details. Add additional plumage, eyes, beaks, and even birdsong. But remember — USE YOUR IMAGINATION. It doesn't have to look like a normal bird — create a flying creature that you see in your mind.

INSPIRATION BUTTON
Can you draw a bird like Picasso?
In 1949, Pablo Picasso's famous continuous line drawing of a dove was adopted by the World Congress of Partisans for Peace in Paris. Picasso's dove is now one of the world's most recognizable symbols of peace. Can you draw a dove in one continuous line movement? Try it out…

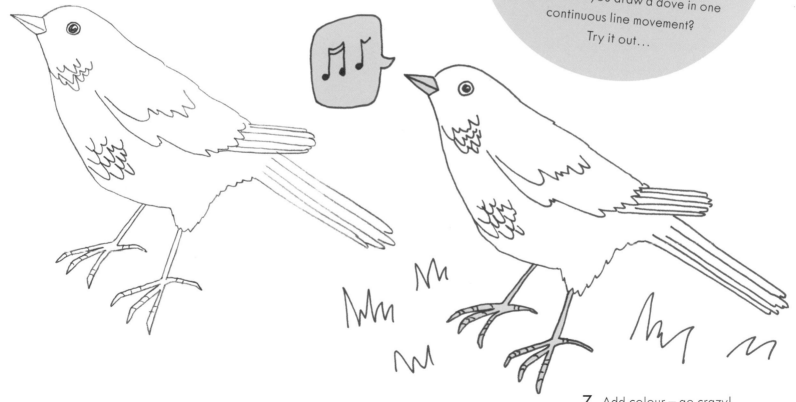

7 Add colour — go crazy!

Making its Mark

THE HISTORY OF INK

Ink is forever. It is as indelible as a tattoo, as permanent as a scar. The history of ink is sewn into the very fabric of human civilization; ink has helped humankind keep a record of our achievements that will last forever, thanks to its particular chemical qualities that make it so hard to wipe away…

Inked Forever

It is often said that history is written by those who hold the pen. But, of course, the pen is nothing without ink. And today's ink has little in common with inks used by ancient civilizations, which makes us wonder — what's next?

2500BC

The Ancient Egyptians and Chinese developed ink at around the same time. They created it by mixing soot, ash or carbon particles (anything burnt!) with a bonding agent, such as beeswax or glue. The Chinese were the first to grind plants and then mix them with water and apply it to ink brushes. Papyrus — made from the pith of the papyrus plant — was the number one writing surface in Egypt. Carbon-based inks, such as soot, were mixed together with gum Arabic and animal glue.

400BC

What we now call India ink was actually invented in China! Made from burnt bones and tar, it was a popular ink at this time. Early scribes using India ink would write with sharp, pointed needles.

AD500–1500

It was during the Middle Ages that iron gall ink become commonplace. Iron gall consists of iron salts and tannic acids, extracted from vegetables. William Shakespeare famously wrote of iron gall ink in *Twelfth Night*, written c. 1602.

AD800–1500

Parchment, made from the untanned skin of sheep and goats and other animals, became a popular choice of writing surface. Quill pens suited parchment much better than reed pens.

> 'Let there be gall enough in thy ink, though thou write with a goose pen, no matter.'
> **William Shakespeare**

1500s

Johannes Gutenberg did more than just invent the printing press. He also started mixing oil with carbon, instead of water, creating the first oil-based inks.

1856

Leave it to English chemist William Perkin to discover synthetic dyes that would eventually become the dominant ingredient in creating commercial inks. Perkin discovered synthetic dyes while looking for a cure for malaria.

1900s

Four-colour printing becomes all the rage. Cyan, magenta, yellow and black are the four colours used in the printing process.

1980s

The early adoption of home computers and printers by an insatiable public saw the rise of production of different types of ink, including solvent, aqueous and UV-curable. Want to know more about these inks? Google it!

Today

With email replacing letters and people accessing more content online, the use of ink is declining rapidly. Before it fades from our lives entirely tomorrow, spread some ink today!

Fountain of Youth

FOUNTAIN PENS

The invention of the fountain pen in 1827 took penmanship to a whole new level of sophistication and elegance. A stylish pen for a stylish age, the fountain pen gave new life to writing, drawing and artistic endeavours. Let's go with the smooth flow and find out more about fountain pens…

Eight Fantastic Fountain Pen Facts
The fountain pen is considered the peak, the king, the champion of all writing instruments. But how much do you know about this complex piece of machinery?

1 Fountain pens work by transporting ink from a sealed cartridge through a hole, into the tip of the metal nib.

2 Using the process of capillary action, the more the nib writes on the paper, the more the ink is drawn out of the nib, which in turn causes more ink to be sucked up from the cartridge, helping ink to flow in a smooth and controlled way.

3 When the nib is lifted from the paper, ink stops flowing to the nib.

4 In AD953, the precursor to the fountain pen, the reservoir pen, was invented when the Egyptian ruler, Abu Tamim Ma'ad al-Mu'izz Li-Din Allah, demanded a pen that would not stain his regal clothes!

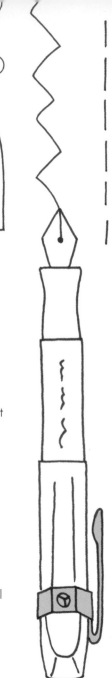

5 It was a Romanian student called Petrache Poenaru who first patented the fountain pen, on 25 May 1827. He invented the concept of a simple, convenient and, most importantly, portable pen with its own ink supply built in while commuting to school in Paris. The eager beaver wanted a way to continue writing notes without stopping *en route* to fill up on ink.

6 Following Poenaru's design, it was Lewis Waterman, a New York insurance broker, who perhaps perfected the modern fountain pen.

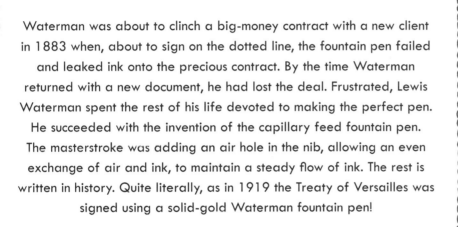

Waterman was about to clinch a big-money contract with a new client in 1883 when, about to sign on the dotted line, the fountain pen failed and leaked ink onto the precious contract. By the time Waterman returned with a new document, he had lost the deal. Frustrated, Lewis Waterman spent the rest of his life devoted to making the perfect pen. He succeeded with the invention of the capillary feed fountain pen. The masterstroke was adding an air hole in the nib, allowing an even exchange of air and ink, to maintain a steady flow of ink. The rest is written in history. Quite literally, as in 1919 the Treaty of Versailles was signed using a solid-gold Waterman fountain pen!

7 John Jacob Parker patented the first self-filling fountain pen in 1831.

8 The oldest fountain pen ever found dates back to 1702.

Just Remind me How Fountain Pens Work?
Fountain pens have four main parts:

a) The reservoir (the sealed cartridge that holds the ink).

b) The nib (the pointy metal end you draw along the paper).

c) The feed (a plastic tube that connects the nib to the reservoir).

d) The collector (a set of grooves just beneath the nib, that collects ink flowing from the reservoir and stops too much ink flooding the page).

How to Draw Eyes

When it comes to drawing, and art, beauty is in the eye of the beholder. When it comes to drawing eyes, beauty is in the holder of the pen. Eyes are the window to our souls, so make sure when you draw them they're not broken windows.

HOW TO DRAW AN EYE

Here's a little exercise for you. Look at your eye in a mirror. What do you see? Let's start with the basics…

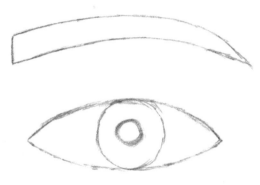

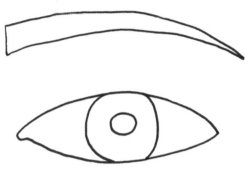

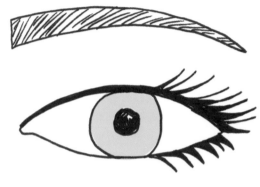

3 Add eyelashes.

1 Make a small curved line for the top of the eye. Then add another small curve for the bottom of the eye to form an oval. This is the white part of the eye, the sclera.

2 Inside the oval, draw a circle. This is the iris, the coloured part of the eye. Inside that circle, draw another circle. This is the pupil.

4 Add detail and colour to this framework, remembering all the details from your eye that you saw in the mirror. What can you remember? Draw…

> 'Drawing makes you see things clearer, and clearer and clearer still, until your eyes ache.'
> David Hockney

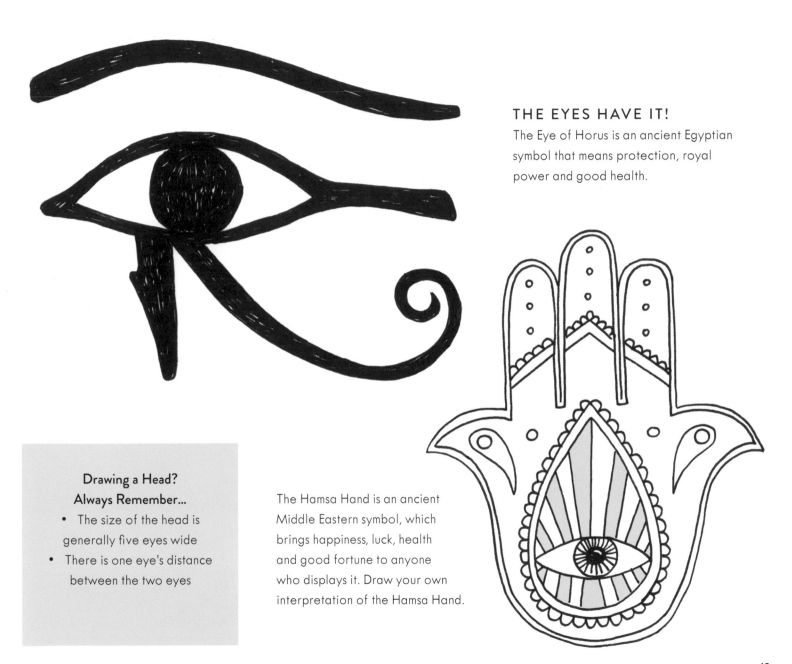

THE EYES HAVE IT!

The Eye of Horus is an ancient Egyptian symbol that means protection, royal power and good health.

Drawing a Head? Always Remember...
- The size of the head is generally five eyes wide
- There is one eye's distance between the two eyes

The Hamsa Hand is an ancient Middle Eastern symbol, which brings happiness, luck, health and good fortune to anyone who displays it. Draw your own interpretation of the Hamsa Hand.

43

Meet Il Lee!

Famed for his ballpoint pen artwork, South Korean contemporary artist Il Lee has been wowing artists all over the world since the 1980s when his work first came to prominence. Let's take a closer look at Mr Lee…

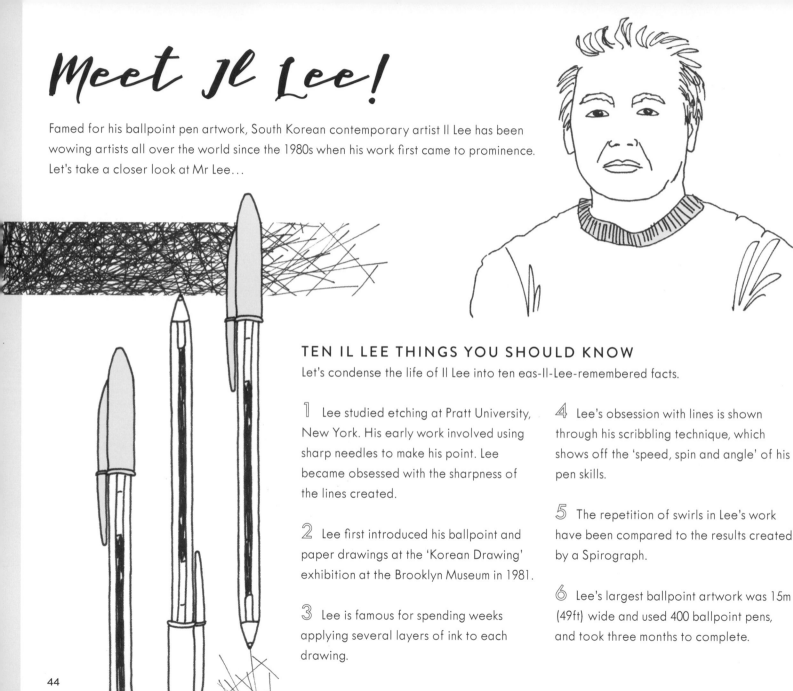

TEN IL LEE THINGS YOU SHOULD KNOW

Let's condense the life of Il Lee into ten eas-Il-Lee-remembered facts.

1　Lee studied etching at Pratt University, New York. His early work involved using sharp needles to make his point. Lee became obsessed with the sharpness of the lines created.

2　Lee first introduced his ballpoint and paper drawings at the 'Korean Drawing' exhibition at the Brooklyn Museum in 1981.

3　Lee is famous for spending weeks applying several layers of ink to each drawing.

4　Lee's obsession with lines is shown through his scribbling technique, which shows off the 'speed, spin and angle' of his pen skills.

5　The repetition of swirls in Lee's work have been compared to the results created by a Spirograph.

6　Lee's largest ballpoint artwork was 15m (49ft) wide and used 400 ballpoint pens, and took three months to complete.

7 Lee's nickname is Pablo Bic-asso, for his prominent use of a Bic ballpoint pen. He is revered by other artists as 'the godfather of ballpoint art'.

8 While some art critics consider Lee's ballpoint artwork as mere 'scribbles', others argue that Lee's use of lines are indeed harmonious and thoroughly thought out.

9 Lee was born in 1952 in Seoul, Korea.

10 Lee was the first artist to use a ballpoint pen as the main instrument of his art. Since him, many others have followed.

GIVE LEE A GO
Put away your Spirograph, and try to replicate the masterful swirls of Lee's scribbles as shown here.

On the Ball

BALLPOINT PENS

Imagine a roll-on deodorant. Imagine rolling it all over your armpits. Feels good, right? That, in a nutshell, is how a ballpoint pen works…but much, much smaller. And less fragrant. Let's zoom in and take a closer look…

Ballpoint Basics

There's lots to learn about ballpoints, so let's crack on with the essentials:

1 Instead of nibs, ballpoints contain a small metal ball, made of brass, steel or tungsten carbide, held in a socket at the business end of the pen. The ball rolls and rotates across the paper, picking up fresh ink stored behind the ball in its reservoir as it rolls along.

2 Ballpoints are the cheapest and simplest – and therefore most popular – pens ever created.

3 Ballpoint pens use an ink paste, which is different from the oil-based ink used in fountain pens.

4 The first ballpoint pen was patented on 30 October 1888 in the USA by John Loud but it didn't catch on.

5 Ballpoint pens were adopted by the British Royal Air Force in the Second World War as normal fountain pens did not work at higher altitudes and pilots needed a fast-drying thicker ink. The ball was the solution!

6 There are 125 ballpoint pens sold every second.

7 Laszlo Biro presented the first prototype of his ballpoint pen at the Budapest International Fair in 1931. He patented it in the UK in 1938, and a new one in Argentina in 1943.

8 14 million 'BIC Crystal' ballpoint pens are sold every day! It is the best-selling ballpoint pen in the world.

THINK SMALL

As a journalist, Laszlo Biro noticed a huge difference between oil-based ink used in fountain pens and ink used in newspaper printing presses. 'It got me thinking,' he said, 'how this process could be simplified right down to the level of an ordinary pen.' With a little bit of tinkering, Biro successfully merged the two together.

YOU NEVER KNOW WHEN A BALLPOINT WILL COME IN HANDY

Neil Armstrong and Buzz Aldrin, the two astronauts onboard Apollo 11 when they became the first humans to step foot on the Moon, accidentally snapped off the switch of a circuit breaker after landing, and they could not take off again without it. Fearing they were stuck on the Moon for ever, Buzz Aldrin improvised. He jammed the end of his ballpoint pen into the hole where the switch had been, and the astronauts' landing module was able to lift off the Moon's surface!

Any one with a pest problem will know this: a mouse can fit through a hole the size of a ballpoint pen!

Pen Pals
Writing to your pen pal in another country? Make sure you're up to speed with the local lingo.

- *Bolígrafo* (Spanish)
- *Penna a sfera* (Italian)
- *Kugelschreiber* (German)
- *Stilolaps* (Albanian)
- *Kuulakärkikynä* (Finnish)
- *Kulpenna* (Swedish)

How to Spin a Biro

Biros are awesome. Not only are they inexpensive, they are light, which makes them really easy to spin around your thumb. This is a really cool move that will impress your friends.

1 Hold the biro between your index finger, middle finger and thumb in your dominant hand — your index and middle finger should be spaced apart from each other by about the width of your thumb. Experiment as to which part of your biro you should grip with. Some people prefer to grip the pen in the middle, near its centre of gravity, while others grip at the end of the pen.

2 Pull or flick your middle finger inwards as if you were pretending to pull the trigger on a gun. This should make the biro twirl around your thumb. If you're having trouble doing this, re-examine your grip. Your middle finger and thumb could be too close to each other.

3 Now, roll your wrist to help twirl the pen around your thumb. Beginners often find they have difficulty making the pen spin completely around the thumb. Rolling your wrist (as if turning a doorknob) as you pull with your middle finger should help.

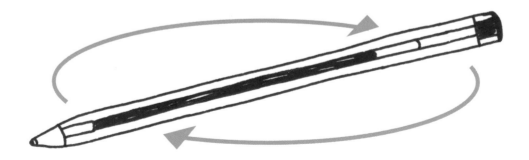

4 Move your fingers out of the way so they don't block the pen's spin. Don't obstruct the pen as it is spinning with other fingers getting in the way. You can stop this by tucking both your index and middle fingers in so that they are under the joint of your thumb.

5 Now for the most important part — catch the biro. The coolest part of spinning a pen is being able to repeat the trick over and over. You can only achieve this by catching the pen at the end.

Practice Makes Perfect

When you pull your middle finger in (like a trigger), remember that too much force will cause the pen to fly out of your hand; but if you use too little force, the pen won't make it all the way around your thumb. Practice makes perfect: in time you'll get a sense of how much force makes your pen spin perfectly every time.

Pens come in all shapes, sizes and weights and all spin differently. Find as many different pens as you can and learn to spin them all. Which one do you think will work best?

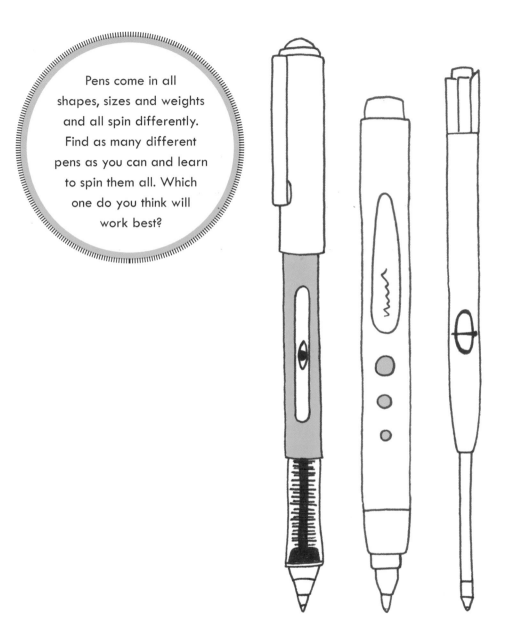

Meet Jean Cocteau!

Writer, designer, poet, playwright, cartoonist, artist, filmmaker, draughtsman, Frenchman: Jean Cocteau was all these things, and a whole load more to boot. A versatile pioneer of the French avant-garde scene that became world famous, the word 'Cocteau' has since become synonymous with the era for which he basically laid the foundation.

SIX COCTEAU FACTS

1 Rising to prominence between the two World Wars, Cocteau became a celebrity in his lifetime, achieving success in many areas. But it is his simple line drawings, and their impact, that we are interested in.

2 Cocteau's line-drawing style was simple, and often cartoonish.

He would use any kind of material he could get his hands on to draw with, including pipe cleaners, hairpins, candles, matches, thumbtacks, lumps of sugar and stars made of pasta.

3 Cocteau outlined his own drawing style in a famous quote that perfectly sums up the artist's passion for life, as well as his art…

'Line is life. A line must live at each point along its course in such a way that the artist's presence makes itself felt above that of the model. … It is, in a way, the soul's style, and if the line ceases to have a life of its own, if it only describes an arabesque, the soul is missing and the writing dies.'

Jean Cocteau

'Poets don't draw.
They unravel their
handwriting and
then tie it up again,
but differently.'
Jean Cocteau

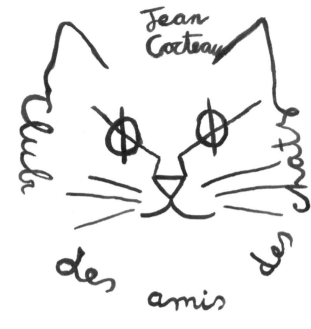

4 Cocteau's love of line drawings best suited his frantic approach to life. The speed at which he could create art, the flow of the line, the weightlessness of a drawing, all summed up Cocteau's attitude to life and his work.

5 Cocteau's masterpiece is the psychodramatic novel *Les Enfants Terribles* (1929), which depicts two adolescent siblings' anxiety caused by their self-imposed isolation as they were growing up.

6 He had a wide and influential circle of friends, including Pablo Picasso, Gertrude Stein, Marlene Dietrich, Coco Chanel, Igor Stravinsky and Édith Piaf — all of whom were pioneers in the French avant-garde scene of the 1920s and '30s.

Pen-mania!

PENS AROUND THE WORLD

Whether you're using a *pero*, *sulepea*, *stylo*, *stift*, *penni*, *caneta*, or *boligrafo*, when it comes to pens the whole world has left their indelible carbon footprint on the page. Let's travel the globe in search of awesome pen facts...

Rome

In 1300BC, the Romans developed an iron/bronze stylus for writing on wax tablets. The stylus was pointed at one end, to write with, and flat at the other, to smooth the tablet when new words needed to be written down.

Spain

The quill pen first appeared in Seville, Spain.

Israel

The Qumran Caves concealed one of the most famous uses of the quill pen in history — writing the Dead Sea Scrolls, which date back to around 100BC.

Ancient Egypt

Juncus maritimus, or sea rushes as they are properly known, were the first plants used to help develop writing on papyrus scrolls. Sea rushes were thinned to make reed pens, the first proper pen ever used.

China

The Chinese were the first on record to use ink brushes. Any animal with hair was plucked and put to good use — camel, rat, weasel, you name it, you can brush with it! Chinese calligraphy is incredibly revered in the country, and the brush used to create masterstrokes was often seen as an extension of the calligrapher's arm — so the nicer the brush, the better the calligraphy.

Italy

A copper nib was discovered in the ruins of Pompeii, which was destroyed by the eruption of Mount Vesuvius in the year AD79.

Croatia

The crafty Croatian Slavoljub Eduard Penkala, an engineer and inventor, developed the first mechanical pencil in 1906. His company, Penkala-Moster, had one of the biggest pen and pencil factories in the world.

UK

John Mitchell, of Birmingham, England, was the first to mass-produce dip pens with steel nibs in 1822. In Birmingham alone there were 13 factories, employing 80 per cent women, dedicated to the manufacture of metal pen nibs for the whole world. The might and power of the machine age, and the popularity of the pioneering dip pens with metal nibs, would become so popular that they helped reduce illiteracy around the world.

Japan

The marker pen first rose to prominence in 1962 in Japan, developed by Yukio Horie of the Tokyo Stationery Company.

Hungary

Ballpoint pens were introduced to the world in the 1940s by the magic fingers of Hungarian inventors Laszlo and Georg Biro.

France

While a student in Paris, Romanian Petrache Poenaru invented the modern-day fountain pen, in May, 1827.

USA

Quill pens were used to write and sign the Constitution of the United States in 1787. Following the end of the Second World War, the whole world went ballpoint pen mad! American entrepreneur Milton Reynolds introduced the ballpoint pen to the US with the Reynolds Rocket, the first commercially successful ballpoint pen, costing $12 each.

Design and Make Your Own Fountain Pen!

Somewhat confusingly, fountain pens are not made of fountains. No, the name fountain refers to the smooth flow and distribution of ink from the nib. However, if fountain pens aren't made out of fountains…what are they made of? And how are they made? Let's make our own…

INGREDIENTS

Fountain pens can be made from a wide variety of materials, usually acrylic resin (otherwise known as Perspex), but for our example today, let's make one out of a block of wood.

Before we begin, scribble a little design of your pen. Think about size, colour, parts, weight, feel and appearance.

1 Prepare the 'blank', a rectangular block of wood that you will file and shape into the two halves of the fountain pen barrel.

2 Drill a hole in the middle of the blank; the hole needs to be big enough for a brass tube, the same shape as your fountain pen design, to be inserted in the middle.

3 Cover your brass tube in polyurethane glue. Make it nice and sticky. Now, insert that brass tube into the hole you made in the blank, using a rotating motion to help evenly distribute the glue. It should fit perfectly.

If you want, why not try making a fountain pen using a 3D Pen! (See page 32)

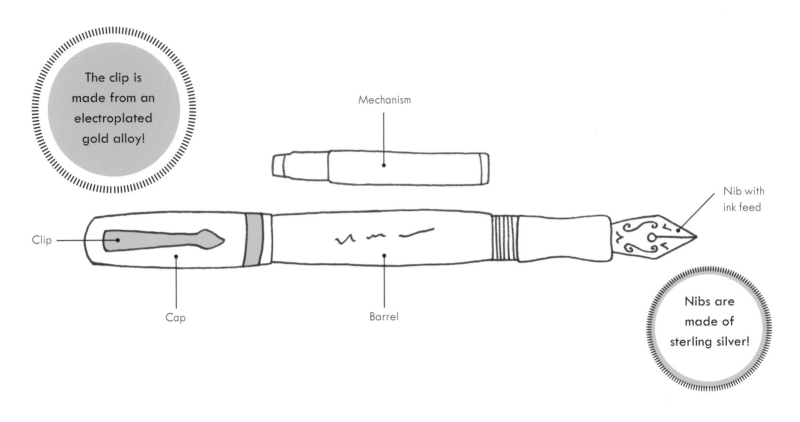

The clip is made from an electroplated gold alloy!

Mechanism

Nib with ink feed

Clip

Cap

Barrel

Nibs are made of sterling silver!

4 Once the tube is inserted, your wooden blank now requires filing and shaping into your design. A split mandrel system is what the professionals use – so go find one!

5 As each blank spins on the split mandrel system, the wood around your brass tube is shaved away, leaving you with a nice round pen-shaped object.

6 Your wooden blank should now resemble a pen barrel, ready for sanding down so it's nice and smooth.

7 Time to assemble your pen. Inside your brass tube, all the contents of the pen need to be inserted in order. Barrel in first (this holds the ink), then the mechanism, then the nib. Finally, the cap.

8 Colour and design the exterior of your pen – let your imagination run riot.

Strike a Posca Pose!

POSCA PENS

From cave walls to papyrus scrolls, animal skin (parchment) to printer paper, and back to walls (for graffiti artists, like Banksy, at least), for several millennia we dedicated scribblers have been writing on any surface we can reach out and touch. With the Posca pen, a whole new world of Poscabilities has opened up...

Posca Pen – What is it?

A Posca pen can draw on any surface and leave its mark! Instead of ink, Posca pens use non-toxic, water-based acrylic pigment paint to express themselves, allowing the pen to be used on metal, cloth, clay, plaster, wood, glass, plastic, plaster, canvas — anything you want.

Location, Location, Location

You'll see Posca pens used everywhere. They are a great way to decorate things you own and add your own vibrant and colourful style and personality. Posca pens are popular with surfers, who add their own colour and designs to their boards. The paint is waterproof. They are also popular with people who want to give their sneakers a flash of personality.

Design Your Own Mug

1 On a piece of paper, scribble the contours of a basic tea mug. Inside the lines, add your design. Let your imagination run wild.

2 Grab a plain white mug.

3 Grab your Posca pen.

4 Shake it! Let the ball inside the barrel get covered in paint.

5 Add your design to the mug. Be careful — keep a steady hand.

Made a Mistake?

Don't worry. With Posca, you can overlay colours as many times as you want.

Paint flow is controlled by a valve and a piston mechanism. Before you start marking anything, start on a piece of paper before use, to better regulate and optimize the flow of paint.

The paint dries in less than a minute!

Posca pens come in a range of nib sizes and colours.

Posca was a popular drink in Ancient Rome and Greece, made by mixing vinegar with water and herbs. Don't try it at home!

Never scribble on antique vases!

Add Colour to Your Life

Thinking of other things to Posca-rise? How about...

1 Shoes
2 Windows
3 Mirrors
4 Clothes
5 Posters

(Don't worry, Posca paint comes off surfaces — but not from clothes or shoes!)

Porous or Non-porous

- Posca pens do not bleed through paper. Magic!
- Any surface that soaks up ink is porous.
- Any surface that does not allow ink to be soaked up is non-porous.

How to Draw Flowers

For centuries, flowers have been an important muse for artists. They represent a powerful, yet simple, symbolic representation of nature — fragile yet resilient. Flowers, like humans, come in all shapes and sizes too, so there are endless variations to keep your hands busy.

FLOWERS ARE BORING?

Many of the most adored still-life paintings in the world have been of flowers. Artists such as Claude Monet, Vincent van Gogh and Paul Cézanne have painted flowery masterpieces. Let's draw a flower and improve our drawing technique…

It's strange to think that flowers haven't always existed. They first appeared 140 million years ago.

FAMOUS FLOWERS

Vincent van Gogh — *Still Life: Vase with Twelve Sunflowers*, 1888

One of the enigmatic Dutch painter's most common muses, Vincent van Gogh loved still-life painting bright yellow sunflowers; he grew them and painted them in order to brighten up his studio. 'The sunflower is mine, in a way,' he once said.

HOW TO DRAW A FLOWER

1 Pick a flower with a strong, structural shape. Here I've picked a camellia, Coco Chanel's favourite flower. Begin by sketching out the basic shape of the flower in pencil — a circle for the head, a line for the stem, and an almond shape for the leaves.

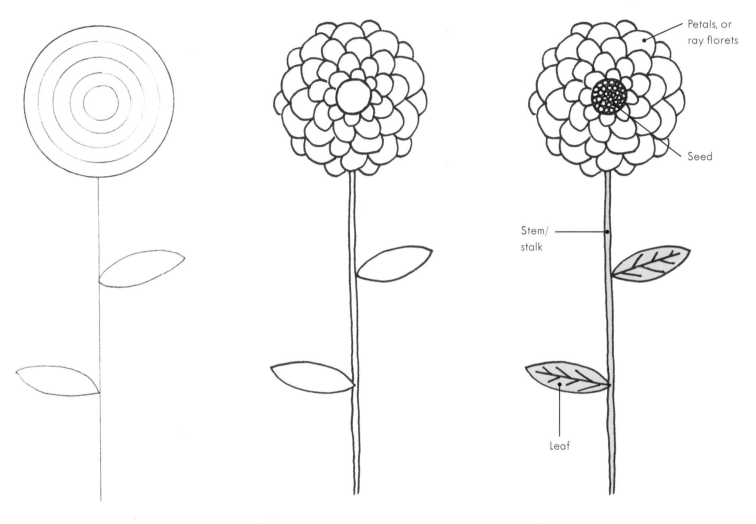

Petals, or
ray florets

Seed

Stem/
stalk

Leaf

2 Inside the circle, still in pencil, draw a series of ever-decreasing concentric circles, which will form a guide for the petals.

3 Now draw in the details in pen, adding petals to the concentric circles.

4 Now add the final details, e.g. veins on leaves, shading etc.

Pens at the Ready

HATCHING

There are many techniques to learn when mastering the art of drawing. You will spend your life constantly learning and evolving your drawing technique. To help get you there faster, let's discover one of the principal skills all drawers must learn — hatching — a technique that gives objects a three-dimensional feel on a two-dimensional surface. Basically, hatching is magic — it transforms your sketch into something else entirely.

It is Leonardo da Vinci, probably the world's most revered draughtsman, who is believed to have first used hatching in his sketches.

What is it?

Hatching and crosshatching are dynamic ways of giving your drawing texture and atmosphere, as well as perspective. These techniques use simple lines in various arrangements and densities to create a sense of light and shade.

Types of Hatching

Hatching is a series of short parallel strokes, or lines. The lines can be made diagonally, horizontally or vertically, but they must always line up and never touch. When lines touch or 'cross' it's known as crosshatching (see page 68).

Rembrandt was a master at using lines to create a real sense of three dimensions on the two-dimensional page. He also used crosshatching to create beguiling contrasts between light and dark.

In hatching, lines never touch.

PARALLEL HATCHING
Parallel hatching consists of rows of parallel lines placed closely together.

Lines always go in the same direction and parallel with each other.

The frequency of the use of lines, and the amount of space between the lines, will allow the drawing to have more light. Less space between lines gives the drawing a darker feel.

Fineliner

Practise Your Hatching

1 Grab your favourite pen.
2 Look at your free hand.
3 Draw it – using your newly discovered hatching skills.

Put your hatching skills to good use with a selection of different pens…

Felt-tip pen

Reed pen

Dip pen

Sometimes lines may curve, depending on the contours of the object. These are known as cross-contour lines.

CONTOUR HATCHING
Rather than simple parallel lines, contour hatching is when the lines follow the contours of the subject.

Fineliner

TICK HATCHING
Tick hatching, well, it looks like this…

Fineliner

What's your Type?

PEN FONTS

In this 21st-century world, we are surrounded, outnumbered and immersed in hundreds of thousands of different and diverse typefaces. The fonts that have been chosen to tell a story, shout out a headline or sell a brand name have been carefully selected to ensure they engage with our minds as fully as possible. Since its first arrival more than 700 years ago, typeface lettering and design has transformed the written word into a visual art form.

Glossary of Type Terms
It can be confusing, but here are the basics:
- **Typography** The *art* of creating the letters we then use in books, magazines and online. Typography is the process of designing fonts, creating them and putting them to good use.
- **Typeface** The *design*, style and look of a specific font.
- **Font** A *set* of letters, designed in a particular typeface.

Historic fonts are usually named after the person who created them. What would you call your font?

TYPOGRAPHY TIMELINE

1400 Along with his printing press, Johannes Gutenberg also developed the most popular blackletter typeface, Textualis. It's not very readable, but it did the job.

1501 The Italian Aldus Manutius created *italics*. Back then, it was a neat way to fit more words onto a page, and reduce print costs. Today, we use *italics* either for aesthetic style or to add emphasis to a particular word.

1757 English businessman John Baskerville created Transitional type, defined by drastic contrast between thick and thin lines. He also created Baskerville, obviously.

1470 Inspired by the flourished script inscribed on ancient Roman buildings, Frenchman Nicolas Jenson created roman type. It spread like wildfire!

1734 Renowned Englishman William Caslon created the 'Old Style' typeface. This features straight serifs — the small line attached to the end of a stroke in a letter or symbol.

Design Your Own Font

1 Grab a piece of paper and a pencil.

2 Start scribbling ideas for fonts you'd like to create. Use your imagination! What do you want your font to look like? Serif or sans-serif? What's your inspiration? Have you thought about geometry?

3 On a piece of paper, draw a series of three-lined grids lightly on the page.

4 The top line of the grid represents the top of a letter, the centre line is the middle of your letter, and the bottom line represents the base.

5 Keep designing until you strike an approach you like.

6 Now do it for every letter of the alphabet. *Voila!*

Go Geo!
Geometry is what you need to consider when you think about designing your font. It is a branch of mathematics that asks questions regarding shape, size, relative position of figures and the properties of space.

It is commonly believed that Max R. Kaufmann's Kaufmann typeface, drawn in 1936, was the first ever handwritten typeface. The TV shows *Pop Idol* and *American Idol* used this font!

1780 French printer Firmin Didot and Italian typographer Giambattista Bodoni created the first modern typefaces — Didot and Bodoni. These fonts were considered very cool. Still are!

1816 Until now, all fonts had serifs. But it was William Caslon IV who created the first typeface without any serifs, a method known as *sans-serif*. At the time, people hated it. It was at this point in history that typefaces exploded as an artform.

1920 American Frederic Goudy started a trend that continues until today. He became the first full-time type designer. He developed and created a multitude of typefaces, including Copperplate Gothic, Kennerley, and, of course, Goudy Old Style.

1957 Max Miedinger, a Swiss designer, and Edouard Hoffman created what was to become the world's most popular font — Helvetica. A very minimal font in terms of design, it spawned the creation of many other simpler typefaces.

Right now! Today, there are thousands of fonts available. OpenType fonts are those that are available, and supported, on any computer. In the 1990s, with the advance of home computers, typographic design bloomed, opening up new possibilities everywhere. Type designers began experimenting with advanced geometry, proportion and design.

Famous Fonts

Pick up a magazine or a book. Look at the fonts. Walk down a high street. Look at the fonts used to sell each shop. Browse online — what do you see the most? Letters of all shapes, sizes and designs. Today, every brand has their own typography style — and it can make or break the design of that brand. The tender love and care, and attention to detail, applied to the creation of these typefaces have made them of vital importance to one of the most important industries in the world — advertising.

Here are some of the more famous fonts in use today:

Helvetica

Designed by Max Miedinger and Edouard Hoffman
Typeface style sans-serif
Created Switzerland, 1957

The original iPhone used Helvetica. Later generations of the iPhone now use Helvetica Neue.

Times New Roman

Designed by Victor Lardent
Typeface style serif
Created England, 1931

After Britain's most-read newspaper, *The Times*, was constantly criticized for being unreadable, in-house designer Victor Lardent created Times New Roman — one of the most readable fonts in the world.

Giambattista Bodoni was known as the 'designer to kings and king of designers' for his work designing typefaces for the dukes of Italy. The magazine *Vogue* uses Bodoni on its cover.

Bodoni

Designed by Giambattista Bodoni
Typeface style serif
Created Italy, 1798

Frutiger

Designed by Adrian Frutiger
Typeface style sans-serif
Created Switzerland, 1974.

Frutiger is the official font of the Euro currency.

Futura

Designed by Paul Renner
Typeface style geometric sans-serif
Created Germany, 1927

Futura is one of the most popular fonts used on film posters, including films like *Gravity*, *American Beauty*, *Gone Girl* and *Interstellar*. It is the favourite font of film director Wes Anderson (and Stanley Kubrick before him) and is often featured in his films.

Garamond is one of the oldest typefaces still in use. It rose to fame during a time of political and social upheaval in France, so new typefaces were created to articulate new ideas to inspire the people to action change. Today, it is used in the Abercrombie & Fitch logo.

Garamond
Designed by Claude Garamont
Typeface style old-style serif
Created France, 1530

Comic Sans was included with Windows 95, making it one of the most widely available OpenType fonts. Today, Comic Sans remains popular with children.

Comic Sans
Designed by Vincent Connare
Typeface style sans-serif
Created USA, 1994

Redraw these brand names in your font!

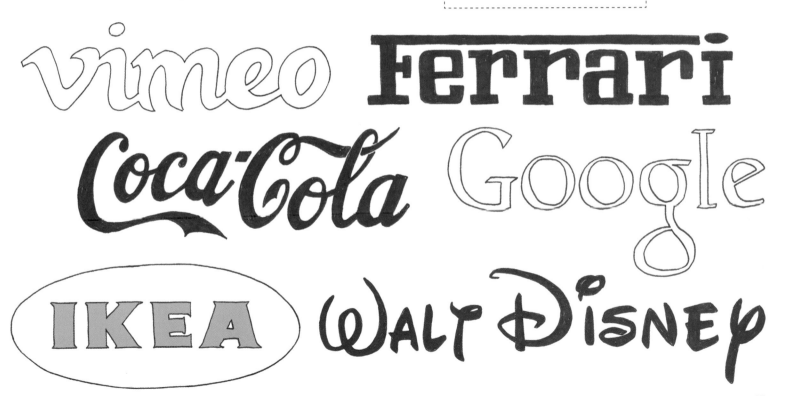

Magic Markers

FELT-TIP PENS

Magic markers, or felt-tip pens, are another handy addition to your pen collection. But felt-tip pens are different from reed, quill, fountain and ball pens, which each have their own unique ink delivery system. Felt-tips — as you might have guessed —have a felt tip and, with their arrival, the world of pens was revolutionized once again.

WHAT'S THAT SMELL?
Magic markers smell of the solvents (the ingredients used to stop the pens from drying out) xylene or toluene; pleasant, heady odours, for sure, but don't smell them for too long!

The Disappearing Magic Marker Trick

In honour of Magic Markers, let's try a fun magic trick that will make your friends laugh — but only at you, if you get it wrong!

Hold a felt-tip pen in your right hand and stand at an angle, so that your friends can only see your left-side profile. Hold out your left hand with your palm facing up. Take the felt-tip pen in your right hand and rest it on your left hand. Now, pull the felt-tip pen back behind your head and bring it back down to your palm, quickly. Repeat this action twice, counting out loud and telling your friends how amazing this felt-tip pen is at the same time. On the third time, however, smoothly slide the pen behind your right ear — which is hidden from view — then bring your hand down swiftly and point to your empty left palm. If you do it fast enough, and emphasize with your right hand that everyone should be looking at your left hand, no one will notice that you have slipped the pen behind your right ear!

Four Fast Felt-tip Facts

1 Lee Newman patented the first felt-tipped marking pen in 1910.

2 The Magic Marker was invented by Sidney Rosenthal, in New York, in 1953.

3 Felt is a type of cloth made by rolling and pressing wool while adding heat and moisture. This causes the wool's fibres to stick together and create a smooth surface.

4 Fluorescent highlighters, which allow text to remain readable after it has been written over, are a part of the felt-tip family.

Make a Rainbow!

One of the greatest drawing techniques all schoolchildren learn is the felt-tip rainbow trick. It's easy to achieve and the result is a multicoloured mini-masterpiece! In the fist of your writing hand, hold a red, orange, yellow, green, blue and purple felt-tip pen with the tips (caps off!) facing towards the page of your sketchbook. Now draw a rainbow!

But don't just stop at a rainbow — draw anything you want, and swap colours as you wish. This is also a great way to draw lots of lines at the same time.

Crayola Markers produce approximately 465 million pens a year!

'X' Marks the Spot

CROSSHATCHING

Another essential linear drawing technique which finesses your drawings and sketches by giving them the illusion of texture and light is crosshatching. This method differs from hatching (see page 60) in one important way — you cross the lines!

Criss-cross

Crosshatching is a method of shading your sketch by drawing small 'X' shapes close together, or further away, depending on how dark an effect you want. This process adds darkness, shade, depth and texture to your sketch.

The master Dutch painter Rembrandt's self-portrait is famous for its exclusive use of the crosshatching method. Check it out!

Crosshatching creates a mesh-like pattern.

The more the lines cross over each other, the darker the value becomes.

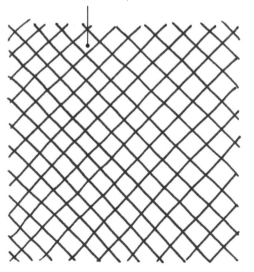

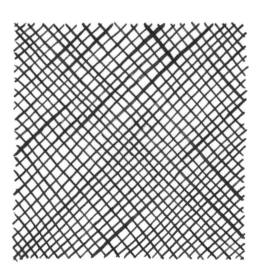

Fineliner

Fineliner

Dip pen

Crosshatching in Action

Here's a crosshatching exercise for you.

1 Put a glass of water under a bright light, such as a desk lamp.

2 Move the lamp as close to the glass as possible.

3 Grab your trusty pen and sketch what you see.

4 Pay attention to the light areas and the dark.

5 For the darker shaded areas, use crosshatching to fill out the shadow created by the glass.

6 Now, move the lamp away, and sketch what you see. The shadow won't be as dark, so you'll have to practise your crosshatching. Use less pressure as you mark your 'X's.

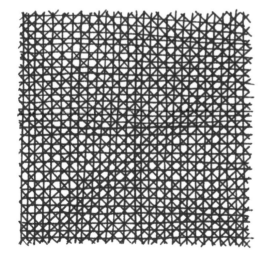

Fineliner

Dip pen

Skin and Ink

TATTOOS

Until the last few years, there has been a stigma attached to tattoos. This is appropriate, actually, considering the Latin word for 'a mark on a person' is *stigma*. However, today we seem to love tattoos — and that too is apt, considering the most popular tattoo type is a heart. Let's look at some facts.

1 Ta – Too!
The word tattoo derives from the Polynesian word 'ta', meaning 'to strike', which describes the sound of a tattooing spike being knocked on skin.

2 West Side Story
Before Captain Cook's famous voyages of discovery around Australia and the South Pacific in 1768, tattoos were known as 'marks'. Upon his ship's return, Joseph Banks, a naturalist aboard the HMS *Endeavour*, first recorded references to the word 'tattoo' in his papers, effectively bringing the word to Europe.

3 Looking Through You
When you look at a tattoo, you're actually looking through the outer layer, or epidermis, of the skin. A tattoo punctures the epidermis, and injects an insoluble ink in the dermis, the second layer of the skin. The cells contained within the dermis layer are more stable than the cells of the epidermis, allowing the tattoo's ink to stay in place.

4 War and Pierce
A machine-driven tattoo needle pierces your skin up to 3,000 times per minute. With every perforation, the needle deposits insoluble ink onto your skin.

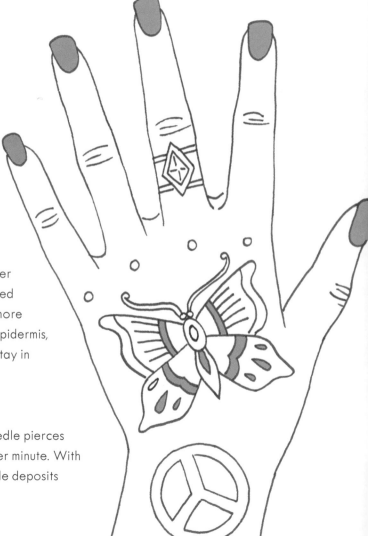

5 Location, Location, Location

The most popular places on a body to get a tattoo are...well, take a guess! Answers below.

6 Just Under the Surface

Tattoo needle machines penetrate one millimetre under the skin.

7 Old Ink

It was the American Samuel O'Reilly who invented the electric tattoo machine around 1891. They haven't changed much since!

8 Anything Goes

Anything that can be ground up and made into a powdered pigment can be used as tattoo ink. Historically, black tattoo ink was made of burnt animal bones, which was then mixed with water.

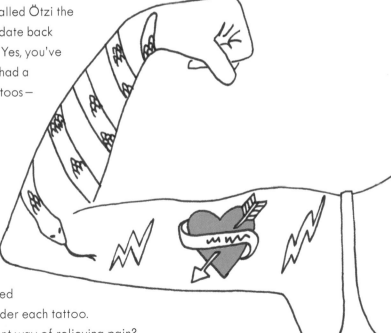

9 Ice Man

The oldest human body ever discovered has been called Ötzi the Iceman. His old bones date back more than 5,000 years. Yes, you've guessed it: the Iceman had a curious collection of tattoos — a black cross tattooed on the inside of his left knee, six straight lines on his lower back, and parallel lines on his ankles, leg and wrists. Interestingly, when scientists X-rayed Mr Iceman's body, they were shocked to find joint disease under each tattoo. Were tattoos an ancient way of relieving pain?

10 Ink Machine

The electric tattoo machine has four parts to it:

1 The needle, which perforates and injects the skin.
2 A tube, which delivers the ink.
3 An electric motor, which allows the needle to perforate and inject the skin. It works like a drill.
4 A foot pedal, to control the flow of ink.

1. Lower back	6. Back-piece
2. Wrist	7. Arm
3. Foot	8. Chest
4. Ankle	9. Breast
5. Armband	10. Neck

Meet Jane Austen!

One of the world's most adored, and important, literary icons, Jane Austen's six novels, packed with charming wit and dancing prose, have remained the greatest insight into 18th-century British society (in particular the role of women and romance), far more than any history book. Yes, Jane Austen changed the world armed only with her trusty goose quill…

**Get Lost in Austen –
Jane's Six Published Novels**

1811 *Sense and Sensibility*
1813 *Pride and Prejudice*
1814 *Mansfield Park*
1815 *Emma*
1817 *Northanger Abbey*
1817 *Persuasion*

HOW JANE WROTE ALL THOSE BOOKS

In Jane Austen's lifetime (1775–1817), the world relied on the feather quill and the pencil as a means of writing and recording everyday lives. For Miss Austen (she never married, of course), her quill pen was everything.

As *Pride and Prejudice* (her most recognizable book) has more than 100,000 words, Jane Austen would have been a serious writer with several sharpened quills on her desk — ready to write the moment a witty line popped into her head.

Metal pen nibs had been invented at the start of the 19th century but were still rare, and much more expensive than using a quill pen.

Jane Austen wrote her novels with a quill made from a large goose feather or a crow feather.

The feather quill is cut at the nib with a knife to vary the thickness of writing, creating a custom writing style for each writer.

Austen's novels were written in her own hand, using a quill pen and ink from an inkwell. She used the most commonly available ink — iron gall ink.

Iron gall ink is composed of tannin (gallic acid) and iron sulphate, gum arabic and water.

When iron gall ink hits the page it appears pale grey. Once exposed to air, the ink darkens to a darker blue-black hue.

TOP FLIGHT FEATHER FACTS

1 Only 'flight' feathers are used for quill pens. One goose can supply 20 good quill feathers every year. In Jane Austen's time, in order to meet the growing demand for quill pens, millions of feathers were imported from all over Europe!

2 Feathers have a natural curve. Right-handed people favour feathers from the left wing, and vice versa — to stop the feather constantly tickling their noses.

3 Feathers cannot merely be plucked and turned into pens. No! Feathers require preparation. This was a quill dresser's responsibility. Feathers were buried under hot sand, a process known as quill dutching, in order to dry out the inner membrane of the feather.

4 Crow feathers were deemed the best choice for women, because they wrote to a much finer point, which suited the smaller handwriting style.

5 The most desirable and high-quality quills were made from swan or peacock feathers.

Quills get soggy and bogged down in ink after too much use. But just give it a good wipe and let it dry — the quill hardens and is ready to use again!

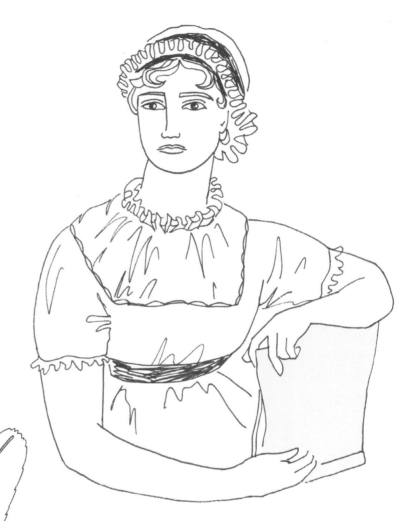

'I must get a softer pen. This is harder. I am in agonies. … I am going to write nothing but short sentences. There shall be two full stops in every line.'

Jane Austen

big it

0111010101010101001010101111010010101010110001010101010101101000101010111101001010
0101011110100101011010101011101000101001001010100010101010001010001100010010
0010100011000100111010101010101010010101010111101001010101010110001010101010110100010
0101011010001010101111010010101011010101011101000101001001010100010101010001010
010010101010001010001100010011101010101010101001010101011110100101010101011000101010

DIGITAL PENS

The 21st century has given the pen a modern reboot. Today, pens no longer require ink to produce masterpieces. Every stroke, every bit of hatching, every line, every scribble, every doodle, they can all now be converted to a digital file and sent straight to your computer. All you need is a digital pen, a tablet…and an imagination!

Take Note

Long gone are the days of scanning your sketches in order to save them on your computer. Now, with digital pens, you can send your sketches straight to your computer's hard drive, where they are safe, stored and ready to be played with.

How Do They Work?

Just like mobile phones have evolved over the past 50 years, so too have pens. Now, in the 21st century, the two technologies have joined forces. A digital smart pen writes like a normal pen, but instead of writing on normal paper, your handwriting or drawing strokes are captured on a special tablet which converts this information into digital data, allowing it to be manipulated in various computer applications.

Digital pens are touch sensitive. They can pick up the tiniest of deviations in your drawing technique.

A digital pen has an inbuilt camera and accelerometer that are so sensitive they can identify your pointillism, crosshatching and other drawing techniques!

Some digital pens have an inbuilt microphone that enables an intelligent Dictaphone, allowing the recording and transcribing of a voice.

Pen base

Wacom tablet

Cintiq screen

'The pen is mightier than the sword, and is considerably easier to write with.'
Marty Feldman

BACK TO THE DRAWING BOARD

Many of our favourite animated films are created with digital pens, giving artists the freedom to breathe life into their characters with their own hands, while also using the assistance of computers to add even more detail. Want to do the same? Check out the Apple Pencil!

Meet Tracey Emin!

One of the most controversial artists of the modern era, Tracey Emin draws the heart she wears on her sleeve, and in the process delivers contemporary art that makes you stroke your chin.

UNIQUE STYLE

Just like fellow modern contemporary artist Damien Hirst, Tracey Emin uses simple pen-and-ink outlines to exhibit moving images of her childhood memories and experiences, often confessional or painful. One of Emin's most famous, and expressive, drawing mediums is monoprinting. This is a technique where the artist draws a line with ink or paint onto glass, and then overlays paper to create a print.

'It took me years to understand the magic of drawing. For years, I tried to make things look how they are – instead of being what they are. Drawing is an alchemic language.'

Tracey Emin

DRAW LIKE EMIN

'Some of my favourite drawings I have done with my eyes closed,' Emin once said. Let's try it out!

1 Close your eyes.

2 What's the first memory that jumps into your mind?

3 Without hesitating, sketch it down with your pen.

4 Keep going until you can't remember any more detail. What have you drawn?

5 Now, add more detail.

'The beautiful thing about drawing: it's intimate, like handwriting, and the dialogue is between the paper and me. If I were left alone on a desert island I would still have the need to draw.'

Tracey Emin

What's in your Mind?

AUTOMATIC DRAWING

Can you draw, or write, without thinking? While there are many methods, techniques and rules to drawing, the truth is, with art there are no rules. Open your mind, unlock your brain and throw away the key — with automatic drawing it's good to set your pen free!

Automatic drawing, or surrealist automatism, was first developed by Surrealist artists such as André Masson and Salvador Dalí.

Automatic drawing is a method of drawing that gives all the power of the artist's mind to their pen. No thinking allowed — just pure creativity.

The Automatic Message, published in 1933 by Surrealist author André Breton, is the most important writing on automatism.

Automatic drawing is the 'thoughtless' creation of random mark-making and subsequent reflection on what has been drawn; in this sense automatic drawing can be a powerful tool for art therapists.

Be Random!

All you have to do to master automatic drawing is simply take a dot for a walk!

Take a piece a paper, grab your favourite pen and free your mind of all thoughts. When you're ready, begin making random marks on the page. Keep going for as long as possible.

Surrealist artists believe that by switching off the conscious part of the brain and switching on the subconscious, automatic drawing will reveal something in the artist's mind that the brain would otherwise override.

Some artists believe that automatic drawing could actually be the possession of the mind by spirits or ghosts!

To improve your drawing technique, automatic drawing can be applied to help you clear your mind, in case you feel swamped by learning too many rules.

Weapons of Choice

TOOLS

It is often said that a bad worker always blames their tools. The same principle should never be applied to drawing.

Kaweco
pen holder

Ink blotter

What Do You Need?
To draw all you really need is a pen and a piece of paper, but these other instruments will ensure precision is part of your work.

1 **Light** make sure you have a good lamp, for artificial light, or have your desk near a window.

2 **Protractor** perfect for drawing smooth curves.

3 **Compass** for drawing a smooth circle.

4 **Ruler and a triangle** a must for drawing right angles and working in perspective.

5 **Space** keep your desk free from clutter. It gives your arms the freedom to move.

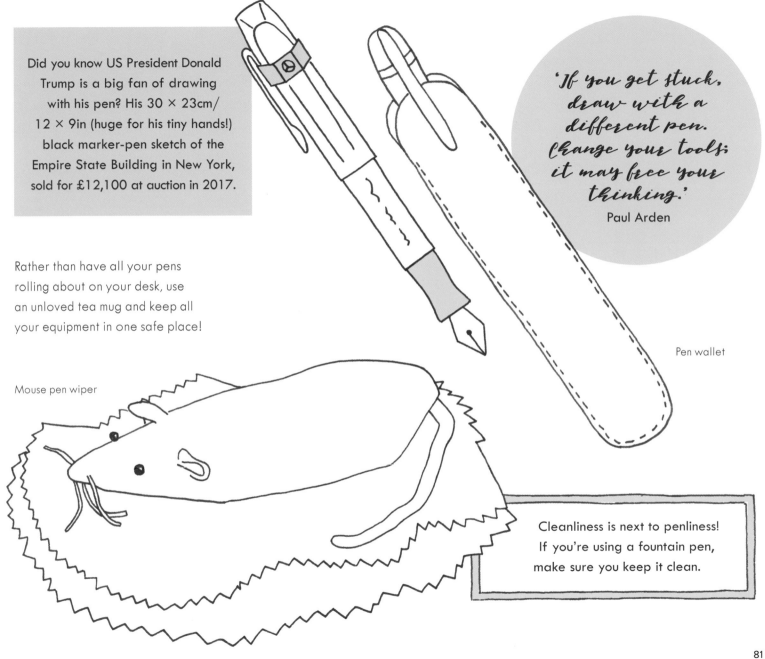

Did you know US President Donald Trump is a big fan of drawing with his pen? His 30 × 23cm/ 12 × 9in (huge for his tiny hands!) black marker-pen sketch of the Empire State Building in New York, sold for £12,100 at auction in 2017.

'If you get stuck, draw with a different pen. Change your tools; it may free your thinking.'
Paul Arden

Rather than have all your pens rolling about on your desk, use an unloved tea mug and keep all your equipment in one safe place!

Pen wallet

Mouse pen wiper

Cleanliness is next to penliness! If you're using a fountain pen, make sure you keep it clean.

Meet Voltaire!

Nom de plume, pseudonym, alias, nickname, anonym, AKA — whatever you want to call it, one of literature's most immortal figures, François-Marie Arouet, sounds much cooler under his assumed pen name — Voltaire!

'To hold a pen is to be at war.'
Voltaire

Pen Names of Famous Writers

- **Mrs Silence Dogood** Benjamin Franklin
- **Clive Hamilton** C.S. Lewis
- **Dr Seuss** Theodor Seuss Geisel
- **Ellis Bell** Emily Brontë
- **Robert Galbraith** J.K. Rowling
- **John Lange** Michael Crichton
- **Mary Westmacott** Agatha Christie
- **Mark Twain** Samuel Langhorne Clemens

TOP TEN VOLTAIRE FACTS

1 Voltaire was born on 21 November 1694, in Paris.

2 Voltaire changed his name in 1718, after being imprisoned in the Bastille.

3 Voltaire never explained why he chose his pen name, but some scholars suggest it's after the word *voluntaire* (volunteer).

4 Voltaire used at least 178 separate pen names during his writing career.

5 Voltaire's writings represented the Age of Enlightenment. He was revered for his intelligence, wit and style!

6 Voltaire wrote for more than 18 hours a day, often never getting out of bed. See below.

7 Voltaire drank as many as 40 cups of coffee a day. See above.

8 Voltaire wrote many influential poems, essays and books over a literary career that spanned 60 years.

9 Voltaire was a liberal; he advocated freedom of religion, freedom of speech, the separation of Church and State, and civil liberties.

10 Voltaire was versatile and prolific; he wrote more than 2,000 books, many of which got him in hot water after he criticized French institutions for their intolerance.

Quick on the Draw

PAPER

'What paper should I use for my drawing?' is a question artists the world over ask themselves every day. Today, paper comes in all shapes and sizes, textures, colours and weights, and it's important to know the essentials as each variety will create a different look and feel. By choosing the right paper, you'll ensure your sketches will look as good as your penmanship.

Make the Grade

For pen art, the paper that you choose is important, and different from what you would choose for paint or a pencil. Thankfully, there are loads of paper sizes and types to choose from!

How do you choose? First, you need to get in the right frame of mind. Questions to ask yourself are:

Paper Sizes

A0	1189 × 841mm
A1	841 × 594mm
A2	594 × 420mm
A3	420 × 297mm
A4	297 × 210mm
A5	210 × 148mm
A6	148 × 105mm
A7	105 × 74mm
A8	74 × 52mm

• What look, feel and style do I want to convey in my sketch?
• Do I want this sketch to last forever or is it just a throwaway sketch?
• What's the purpose of this sketch?

Paper Weight

A paper's weight, or thickness, refers to how dense a sheet of paper is. The higher the number, the thicker that sheet of paper. Paper density is measured in grams per square metre, or gsm. Here's a quick guide:

- **74gsm** fax paper
- **90gsm** printer paper
- **120gsm** brochures
- **165gsm** birthday cards
- **175gsm** postcards
- **200gsm** playing cards
- **250gsm** business cards

Drawing Paper

Pads of plain white A4 drawing paper, with a paper weight around 90–100gsm, are perfect for sketching and doodling. If you want something harder, illustration board or Bristol board will do the trick!

Paper, as we know it today, was first developed in China in AD105 by Ts'ai Lun, of the Han dynasty. Lun invented the first papermaking process. He used rags (waste, from textile manufacture) as the raw material with which to make paper. Until this point, paper had been produced from papyrus (grass) or parchment (animal skin).

Paper Grades

There are three types of paper grade.

1 **Paper** the lightest weight. Anything that can be folded!

2 **Index** not foldable, perfect for business cards.

3 **Cover** all book covers are made of this grade of paper.

Want to know the word for when your paper dries all wrinkly after getting wet? It's cockling!

The type of paper you choose for your pen-and-ink drawings matters significantly to the final look of the sketch.

85

Magic Fix

HOW TO CORRECT ERRORS

Pobody's nerfect, everybody makes mistakes. Drawing is no different. In order to master your masterpieces, first you must fill your rubbish bin with scraps of crumpled-up paper. The road to perfection is bumpy, but practice makes perfect...

Stating the Obvious

You can rub out a pencil mark. With pen and ink, fixing your drawing — it's a bit trickier! So, you need to make sure that, before you begin your final sketch preparations, you know what you're doing and how you're doing it.

Concentration is key. Make sure you drink water. Dehydration can account for a serious lack of concentration.

Five Ways to Fix a Mistake

1 INCORPORATE!

OK, so you've made a mistake. Don't panic! Can you incorporate the slip-up into the drawing, if you've drawn a line where you shouldn't have done?

2 PAINT IT WHITE!

White correction fluid, better known by its brand name Tipp-Ex, could cover up the error. And general white paint, used to decorate your bedroom walls, can also be useful to cover up any wandering lines. Ask Dad if he has any spare.

3 COVER UP!

Gone over the lines? Drawn something you shouldn't? Cut a square of white paper from another piece of paper, the same type you are already using, and glue it to your drawing. And then draw over that. This is called a 'patch'. It will be visible, but it will mean you won't have to start from scratch.

4 SCRATCH!

Grab a sewing pin — remember to be very careful — and scratch very lightly at the paper. By lifting up the top fibres of the paper, sometimes you can make an error disappear. But don't scratch too hard, or you'll damage the paper even more.

5 COMBO!

Sometimes a combination of the four methods above may steer your drawing back to the safe zone.

Common Mistakes

If you're making lots of mistakes, chances are this is where you're going wrong…

SPILLED INK

Ink is a notorious troublemaker in the art world. Leaks, spills — perhaps you've nibbled on your pen too much, or dropped your pen? Ink can get everywhere. If the spill is too great, trace your drawing (or the parts you like), and start again. Tracing paper is a must for all beginners. See Tools, page 80.

INK SMEARS

If you don't let your ink dry properly, and you swipe the back of your hand over a drawing, the ink could smear and ruin your sketch.

SPILLED WATER

Wet ink and water do not play nicely together. It can cause a horrible stain. Keep your glass of water away from your desk. You don't want to spoil your pretty picture by being clumsy! It happens to the best, but it can be avoided! Likewise, if you're sketching outside and it starts to rain, make sure you have something to cover your work up with.

INK RUNS OUT

If your pen runs out of ink, never ever, ever, start using a different type of pen. The difference will be noticeable. Always make sure you have the same pen as backup with you whenever you sketch. Otherwise you'll be left high and dry!

If you can't fix your drawing — start again!

Pen Quotes #1

Pens have changed the world. But don't just take our word for it...

'I bought a seven-dollar pen because I always lose pens and I got sick of not caring.'
Mitch Hedberg

'It's called a pen. It's like a printer, hooked straight to my brain.'
Dale Dauten

'I'm a good scholar when it comes to reading but a blotting kind of writer when you give me a pen.'
John Millington Synge

'There is no lighter burden, nor more agreeable, than a pen. Other pleasures fail us, or wound us while they charm; but the pen we take up rejoicing and lay down with satisfaction, for it has the power to advantage not only its lord and master, but many others as well, even though they be far away – sometimes, indeed, though they be not born for thousands of years to come.'
Petrarch

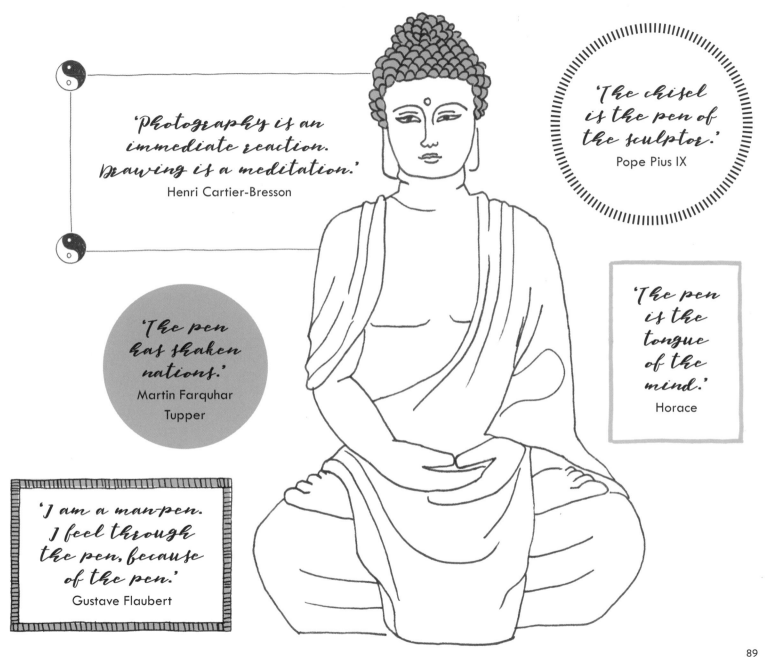

'Photography is an immediate reaction. Drawing is a meditation.'
Henri Cartier-Bresson

'The chisel is the pen of the sculptor.'
Pope Pius IX

'The pen has shaken nations.'
Martin Farquhar Tupper

'The pen is the tongue of the mind.'
Horace

'I am a man-pen. I feel through the pen, because of the pen.'
Gustave Flaubert

89

The Writing's on the Wall

THE TRUTH ABOUT PENS

A lot has been written about the humble pen. Much can be written about it. Its history, its future, its evolution, its inner workings, its flaws. Want to know the truth about pens? Look no further. Here are some easy-to-remember, hard-to-forget pen facts...

Pens can learn. If you use a fountain pen with a gold nib, over time the soft metal will slowly change and adapt to your writing style.

Since 1950, the world's largest manufacture of pens, Bic, has sold more than 100 billion ballpoint pens globally. That's 13 pens for every person alive today and enough ink to draw a line to the Moon and back more than 320,000 times.

A biro takes five minutes to make and can write up to 45,000 words.

An estimated 15 million biros are sold every day worldwide!

The 'average' person — whoever that is — uses more than 4.3 different pens per year.

The 'space pen' was, contrary to belief, invented in the private sector and was simply popularized by NASA! Paul C. Fisher of the Fisher Pen Company had, by 1965, produced a pen that could work upside down, underwater, at temperatures from -45°C to 204°C (-49°F–400°F), and even, you guessed it, in space. The official name of the pen: 'AG-7'!

The most pens used in a presidential signing was by Lyndon Johnson. He employed 72 pens when he signed the Civil Rights Act of 1964, one of the most important documents of the 20th century.

Own a pen with a brand logo on it? Then, you're one of the 56 per cent of people in the world who do!

Pen clips were invented in 1905.

Every time the President of the United States signs a new law, or bill, or important document, they sign their name with a different pen. Often multiple pens! The pens are never used again for signing, and are offered as thank-you gifts to important people. This pen-tastic tradition dates back to Franklin Delano Roosevelt, President from 1933–45.

President Barack Obama used 22 pens to sign the 2010 healthcare reform law known as Obamacare. He used a different pen for each half-letter of his name. 'This is gonna take a little while,' he said while signing!

A ballpoint pen uses thick oil-based ink. A rollerball pen uses liquid ink.

Decorated with 945 black diamonds, 123 rubies and valued at $9 million, the 'Fulgor Nocturnus' is the world's most expensive fountain pen. The only one of its kind, it was hand-made by Italian pen-makers Tibaldi in 2010.

What's the first thing you do with a new pen? Studies revealed that in 95 per cent of cases, the first word written is...drum roll... your own name!

How to Draw Manga

The first manga drawings appeared in 1947, when Japanese artist and 'father of manga' Osamu Tezuka released *Shin Takarajima* ('New Treasure Island'). Four years later, Tezuka's *Tetsuwan Atom*, or *Astro Boy* as it became known in the USA, became the beacon for manga as it entered the mainstream all over the world.

WHAT IS MANGA?

Today, manga is a style of art based on the Japanese comic book style in the 1940s. The style is defined by characters who employ speed, movement lines and sharp-angled features, as well as complex and dramatic action storylines, often about a group of friends who battle strange enemies to protect the Earth.

THE EYES HAVE IT!

How to Draw a Manga Face

Before you begin your sketch, familiarize yourself properly with the manga style, paying close attention to movement lines and expressions.

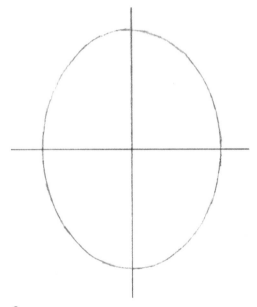

1 To begin your manga character, first draw an oval for the head. Manga characters have sharp features, so feel free to add extra points to ears, eyes and mouths.

2 Inside the oval, draw a vertical line beginning at the top of the circle and ending below the circle by about half the circle's length. This will be the guideline for your character's chin. Now, draw a horizontal line, halfway through the vertical line. This will be the guideline for your character's eyes.

3 Add eyes, nose and mouth to your character's face. Manga mouths and noses are usually defined by sharp pointy lines, and very little else.

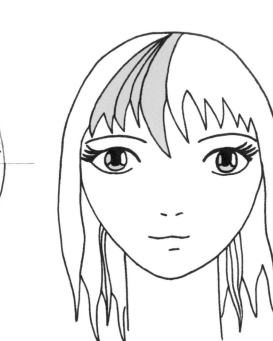

Older manga characters have longer chins and slender faces. Younger characters have shorter chins and rounded faces.

A manga artist's weapon of choice is a technical pen, chosen for its precise line widths, small tip sizes and reliable ink flow.

4 The eyes are the most striking and defining part of a manga character's face. Girls' eyes always have longer eyelashes than boys, and the eyes always have light glares. To draw these light glares, draw three circles.

5 The character's neck should be lean, taut and straight. It's the gateway to the body's language and expression, so must tense and flex accordingly. You can show this by using straight lines for the contours, and stress lines to indicate movement.

6 Hair is also very important. The pointier and sharper the better! Manga is characterized by expressive use of vibrant colour, especially for younger characters. Loud greens, vivid blues and neon pinks — go crazy!

Meet Rodolphe Töpffer!

In the 1830s, Genevan Rodolphe Töpffer effectively invented a new art form and a phenomenon that would go on to enthrall and entertain the 20th century: the comic strip. Today, we call it the graphic novel.

Töpffer had very bad eyesight so his drawing style was very simple — doodles, basically. Broken lines, imperfections, done with pace. All his doodles were pen and ink — black on white.

Töpffer created seven titles, with their own characters:

1 *Histoire de M. Jabot*
2 *Monsieur Crépin*
3 *Les Amours de M. Vieux Bois*
4 *Monsieur Pencil*
5 *Le Docteur Festus*
6 *Histoire d'Albert*
7 *Histoire de Monsieur Cryptogame*

THINK INSIDE THE BOX

Comic strips are the foundations of much of our storytelling in the 21st century. Many of the biggest characters in comics — think Iron Man, for instance — all started life confined to a small cell block, a comic strip.

Let's start by making our very own three-panel comic strip. Don't be afraid to think outside the box — feel free to have your characters move in, around, on top and underneath the panel cell, if that's what you want.

1 First thing you do is, in your sketchbook, come up with a story, joke or idea that you want to put into comic strip format. A three-panel comic strip is easiest — it lets you set up a story, build it up, and then deliver a punchline.

2 When you have your three-panel idea, quickly sketch it out in your sketchbook, remembering to write down funny words, phrases or jokes you wish your character to say. Think about your drawing style and tone.

3 Choose your size. Most newspaper cartoons are comprised of three to four 7.5cm (3in) panels. For this example, draw three 7.5cm (3in) panels. Use a ruler. Draw straight (unless you *want* it to appear on an angle).

4 Begin drawing your comic. Focus on one panel at a time. Draw with a light pencil so that you can alter things easily. As you draw, remember to leave space for speech bubbles or dialogue boxes.

In 1842, *Les Amours de M. Vieux Bois*, translated as *The Adventures of Obadiah Oldbuck*, became the first comic book ever published in the USA. By appearing in magazines they were the first comics reaching a mass audience, thus proving its commercial potential.

5 When you're happy with your drawings, go over the lines with your pen, and add colour.

Use squiggles to give your comic strip's background and foreground some value of light and dark. Don't leave it blank!

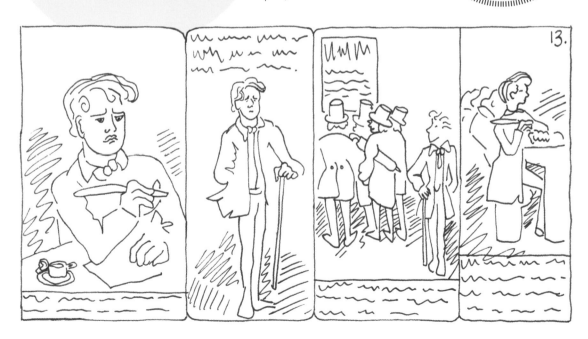

Don't Join the Dots

STIPPLING

First developed by Giulio Campagnola around the year 1510, stippling is a popular technique that will give your sketches an extra-dimensional look and feel.

What is it?

Stippling is simple. It's the creation of a pattern using small dots. Like hatching and crosshatching, it is a great technique to add shade or solidity to your sketch.

If you want to sketch a scene with darkness and shade, you will need more stippling. The higher the density of dots, the more time it will take to produce a good-looking sketch, so if you just want to do a quick sketch, but still need dark values, use a pen with a larger nib!

Draw the outline of a cube in pencil.

In fineliner pen, draw over your pencil lines. Then, on the right-hand side plane of the cube, fill the square with densely packed dots. This will be the side in darkest shadow.

Now move to the top plane, and fill the shape with significantly fewer dots, spaced widely. This is the side with the least shadow.

How to Stipple Shapes

Practise stippling with a pick 'n' mix of shapes.

1 Draw the contours of different shapes — a cone, a square, a rectangle, a cylinder.

2 Think: where is the light source coming from? This is what will determine the density of your dots for the shaded area.

3 Start stippling: always begin with the darkest point, where the higher concentration of dots will be required. Just lift your pen off the page and set it back down again, making sure you mark a dot, not a line or a dash. Move slowly and concentrate.

4 Evenly space out your dots. On your shapes, try different sides to show the movement of light.

The light source is coming from the right!

The light source is coming from the top!

Finally move onto the left-hand plane of the cube, and fill the square with a medium amount of dots, halfway between the lightest and darkest. This is the plane in medium shadow. And voilà! You have created a 3D cube. Try this technique with other simple 3D shapes — how about a cone, a cylinder or a sphere?

To put stippling to best effect, use a fine-point pen with a 0.1mm nib. The smaller the nib, the better!

The light source is coming from the left !

Meet Paul Klee!

Born in Switzerland in 1879, Paul Klee grew up to become regarded as the master of line drawing. Indeed, it was Klee, who as an older artist taught at the prestigious German Bauhaus School of Art, who poetically captured the simplicity of art with one of his most famous sayings: 'Drawing is simply a line going for a walk.'

'Colour has taken possession of me; no longer do I have to chase after it, I know that it has hold of me forever... Colour and I are one.'

Paul Klee

KEY KLEE FACTS

1 Unlike other artists whose work falls into one stylistic genre, Klee's art was influenced by a variety of styles — Cubism, Surrealism and Expressionism.

2 From 1921–31, Klee's pen-and-ink sketches, alongside his views on art, were published in *Paul Klee: Notebooks*. These drawings and thoughts are highly acclaimed.

3 Klee was famous for his use of a variety of pen types. Throughout his career, he used a scratchy quill, home-made brushes and reed pens, toothpicks, razor blades and bits of wire. Anything he could use to make a mark, he did.

4 Klee was super-prolific. He completed more than 10,000 pieces of art in his lifetime. You'd better get cracking if you want to catch up.

5 Klee was a wizard with his pen and India ink. When he combined his natural draughtsman talents with his knowledge of colour, he created an individualistic style that was instantly recognizable. The finest example of this is his 1919 painting *The Bavarian Don Giovanni*. Check it out!

6 Klee's masterpiece is *Ad Parnassum*, 1932. It is defined by its pointillism — a drawing technique similar to stippling (see page 96).

Swept Away!

THE BRUSH PEN

A brush pens may look like just a normal ol' pen, but look again. If you've ever wanted to master watercolour art like the masters J.M.W. Turner and Vincent van Gogh, but didn't want to make a lot of wet and soggy mess, then a brush pen is just what you need, and is a great way to add a bit of colour to your sketches.

A brush pen has a cone-shaped nib, but no bristles like a paintbrush. This allows loads of flexibility, giving you the freedom to paint thick downstrokes and thin upstrokes.

Down on the Upside

When drawing downstrokes, increase the pressure on the nib. This will create a thick line.

When drawing upstrokes, decrease pressure on the nib, and write tenderly. This will create a thin line.

THAT'S OLD!
Pen scientists believe that ink brushes were invented in China more than 2,500 years ago, and were made out of a bundle of goat hair attached to a bamboo tube.

Hold your brush pen like you would hold a regular pen.

Brush Lettering

Brush lettering relies on different degrees of pressure to produce various results. Let's practise the technique…

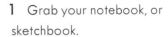

1 Grab your notebook, or sketchbook.

2 Think of a word that will fit the page, say, T E L E V I S I O N.

3 With your brush pen, practise writing the word in a variety of styles.

4 Try swirly flourishes, by using less pressure, and thin upstrokes.

5 Try straighter lines, by using harder pressure, and thick downstrokes.

6 Use different pressures for different letters — spot the difference!

7 Try practising your name, or your signature, in brush lettering.

Once you feel you know what you're doing, try drawing a tree. Use thick downstrokes for branches and roots, and light upstrokes for finer details like leaves and twigs.

The News at Pen

REPORTAGE DRAWING

Drawing is much more than just sketching what you see with your eyes. Drawing is about capturing moments true to life. Reportage drawing, the art of drawing an event as it happens — 'visual journalism', if you will — is the reporting of the news but with a drawing instead of a sentence! From courtroom sketches to warzone drawings, reportage helps document the facts as they unfold…

During the First World War, sketch artists were sent to the front line and no-man's land, where all the fighting occurred. It was their sketches that reported the horrors of war.

Just the Facts
Reportage drawing must be completed at the location as the event is happening, and has to show the world around the event, not just the event itself.

Life is happening around you all the time — draw it!

The Draw of the Law
Courtroom sketches are used all over the world to document and capture the details of trial cases, often because in many courtrooms news cameras are not allowed in order to preserve privacy for those involved. This is reportage drawing!

What do you see when you look out of your window?

Look out of your window

1 Focus on an event happening — for example, someone walking their dog.

2 Draw the event as it unfolds. Sketch the contours of the person and the dog — and then draw any remarkable detail that stands out. Be quick!

3 Now draw the world around the person and the dog. Draw the houses, the trees, any cars, a neighbour waving hello.

4 Remember, your drawing is reporting the news as it happens, so the more facts, the better.

Ready, Set, Scribble!

Scribbling is great fun — just grab your trusty pen and take a line for a run!
Don't worry about form or technique, just scribble what you see.

SCRIBBLE EXERCISE

Look at the following objects below — a candelabra, a chair, a lamp, a plant. Everyday items you see around your house. But have you ever thought about scribbling then?

1 Take five seconds to scribble each one. Draw the contours only.

2 Take ten seconds to scribble each one. Draw as much detail as you can.

3 Take 20 seconds to scribble each one.

4 Can you see the difference in your scribbles?

How would you define your scribbling style? Are you a messy scribbler or a tidy scribbler? Are your lines tight and angled, or loose and messy?

Make your hand all floppy before you scribble!

INSPIRATION BUTTON
Scribble the Rhythm
In honour of the inventor of the scribble line, Florence Cane, play songs from different genres of music and scribble how the music makes you feel. When you're finished, analyze the lines of your scribbles.
Can you spot the difference?

Don't confuse doodling with scribbling! A random drawing produced while your mind is distracted is called a doodle.

How to Draw a Townhouse

Drawing is all about shapes. And shapes are built by lines. The only thing stopping you from becoming a master artist is your imagination…and what you do with those shapes and lines. Whether you're drawing a cat, dog, a bowl of fruit or a skyscraper, if you get your shapes right, you'll be in tip-top shape to design a masterpiece.

BUILD IT

Buildings, and architecture, have long been a frequent inspiration for an artist's pen, from master painters such as van Gogh and Gustav Klimt. There is something about a building's use of shapes and lines that attracts a draughtsman's eye. So, let's draw one!

Shapes, Shapes, Shapes

As with all drawings, it's all about shapes. Roofs are triangles, walls are squares and windows and doors are rectangles. A townhouse, a slender and tall building, is perfect — it contains all the shapes we need: circle, square, rectangle, hexagon, cone and triangle.

What pen type will you choose? Architects draw buildings with technical pens (see page 108).

If you want precision with your building's lines, use a ruler!

For the contours of our townhouse, draw a rectangle. On top, draw an equilateral triangle.

Inside the rectangle of the townhouse, draw the contours of windows and doors.

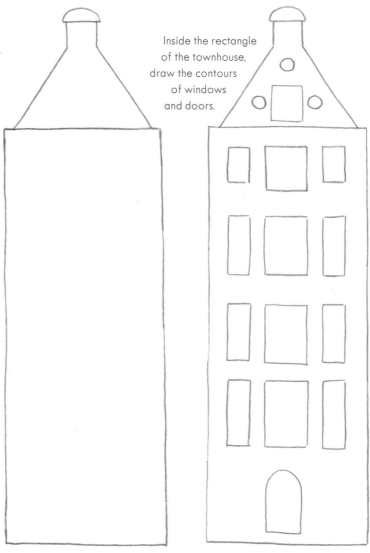

Add more details, ornamental devices and any elements that give your townhouse more definition.

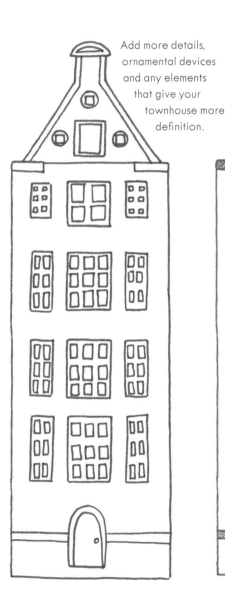

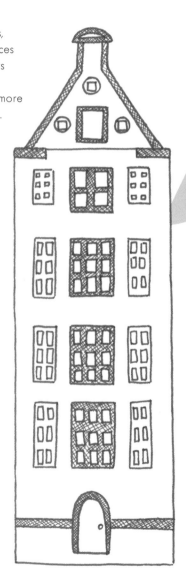

TRY A TRIANGLE!

Triangles are the strongest shape found in nature and they are the shapes most commonly employed in construction because of their great strength. It's the reason why the pyramids of Egypt, some of the oldest buildings in the world, are just big triangles!

There are six types of triangles and each one is stable and rigid:

- **Equilateral triangle** Three sides of equal length and three equal angles.
- **Isosceles triangle** Two sides of equal length and two equal angles.
- **Scalene triangle** No sides of equal length and no equal angles.
- **Right-angled triangle** Has one angle that is exactly 90 degrees.
- **Obtuse triangle** Has one angle larger than 90 degrees.
- **Acute triangle** Has angles that are all less than 90 degrees.

Choose a drawing technique to best represent light and shade, such as hatching, stippling or crosshatching. Which one works best here?

Technically speaking

TECHNICAL PENS

The precision weapon of choice for architects and engineers, technical pens are also a favourite tipple for artists too. With their ultra-thin tips delivering super-fine lines of consistent width, technical pens are just what you need when you want to pay attention to the small print…

Perpendicular Pen!

Unlike other pens, which work best when held at a 45-degree angle, a technical pen works best when held upright at a 90-degree angle (also known as perpendicular). Why? Because it gives a much more stable flow of ink, which results in fine, consistent lines.

The metal tips of technical pens range from 0.03mm – the tip of a needle! – to 1.4mm. Unlike other pens, which produce lines of different widths depending on how much pressure you apply, technical pen tips only draw a line of a single width.

Precision Perfect Picture

To get the most out of your technical pen, pick up other drawing tools that will give your drawing more precision:

1 Drawing head
2 Set squares
3 Shape templates
4 Text stencils

Look after your technical pen — it is reusable.
When you run out of ink, refill the reservoir
using an ink bottle. These are sold separately.

A Bird's-eye Blueprint

Technical pens are used to draw up blueprints and design schematics for buildings and appliances. Before any townhouse is built or kettle is made, it starts life as a sketch. Let's put your technical pen to good use and draw up a bird's-eye blueprint of your bedroom.

1 Grab an A3 sheet of paper.

2 In your head visualize your bedroom as if you're looking down at it from above. Like a bird!

3 Draw the outline shape of your bedroom. Most bedrooms are squares or rectangles.

4 Draw the location of any doors and windows. Mark these up by using a dotted line. Indicate which way the door opens.

5 Draw the outline shape of your bed, wardrobe and other furniture in the location of your bedroom. Are they located in the corner, under the window or near the door?

6 When drawing the furniture, pay attention to size. How far along the wall does the bed stretch? Be as precise as possible.

7 Are there any other features of your bedroom to add?

8 When you have finished drawing your own bedroom, draw the rest of your house.

Learn Your Lines

LINEWEIGHTS

As we all know now, 'a line is a dot that went for a walk'. But lines aren't just straight, they come in all shapes, styles and sizes – thick, thin, light, hard. Lines have tone and texture, can point in any direction and draw any shape. Lines can even be dotted!

LINE LINGO

Lineweight The strength, heaviness or darkness of a line.

Horizon line The height of the viewer's eye. This is most apparent in landscapes.

Orthogonal lines Lines that reach back and converge at the vanishing point on the horizon line.

Implied line A line with a small break in it from where you have lifted up your pen from the paper. Your mind fills in the gaps, and still thinks the line continues… because it's implied that it does!

Contour line A line that defines the outline of an object. Quite simply, it is used to create an outline drawing.

Centre lines A cross hair used in portraits to ensure faces are symmetrical.

How to Draw a Straight Line – Without a Ruler!

1 Draw a dot on your paper with a pencil where you need the line to start.

2 Draw another dot on your paper where you want the line to end.

3 Now, place your pencil at the first dot. This is where your line will begin.

4 Focus your eyes on the second dot. DON'T STOP LOOKING AT THAT DOT!

5 Begin drawing the line until it reaches the second dot. DON'T STOP LOOKING AT THAT DOT!

6 Congratulations! You just drew a straight line without using a ruler.

Remember angles! Draw a line while holding the pen at a 45-degree angle. Now, with the pen standing upright at a perpendicular angle, draw a line using only the very tip. Spot the difference!

Open the Bottle

A bottle is a great way to practise drawing various lineweights.

1 Begin by sketching out the bottle in pencil, drawing in the main shape of the bottle, the bottle top and the label.

2 Now take the 0.8mm pen and draw in the outline of the bottle.

3 Next take the 0.3mm pen and draw in the outline of the label and bottle top.

4 Finally take the 0.1mm pen and draw in the fine details — the typography on the label, the ridges on the bottle top — and hatching for the shadow.

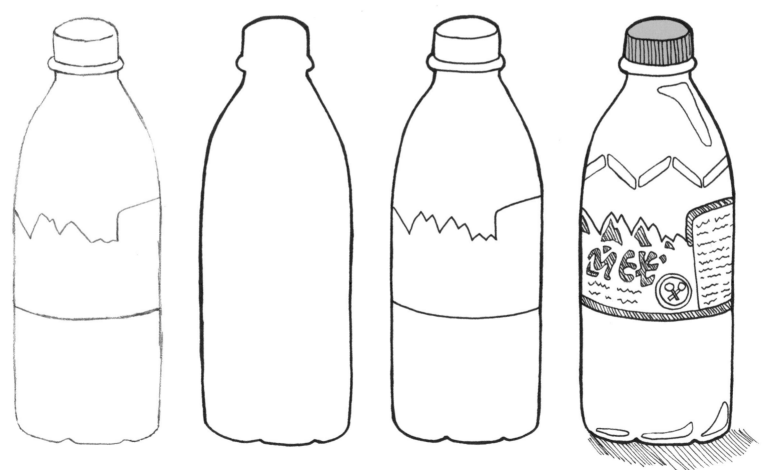

Draw, Cut, Repeat

REPEATING PATTERNS

Drawing doesn't just stop once you put your pen down. No! With repeat patterns you can cut up and reassemble your sketches to create totally unique and awesome designs that not only show off your penmanship, but also your art skills too, because repeat patterns are where art and drawing combine to create something new.

Repeat, Repeat, Repeat
Repeat patterns are a little tricky to get right first time, so pay attention!

B

A

1 On an A4 piece of paper, draw your design with your trusty pen. A collage, for example, of five objects — a face, sunglasses, a shoe, a hand, a bike — or whatever you wish! Ensure your drawings don't touch the edges of the paper.

2 Using a pair of scissors, score a line down the middle of the paper, and then cut through the middle of your sketch. Don't panic!

B A C D

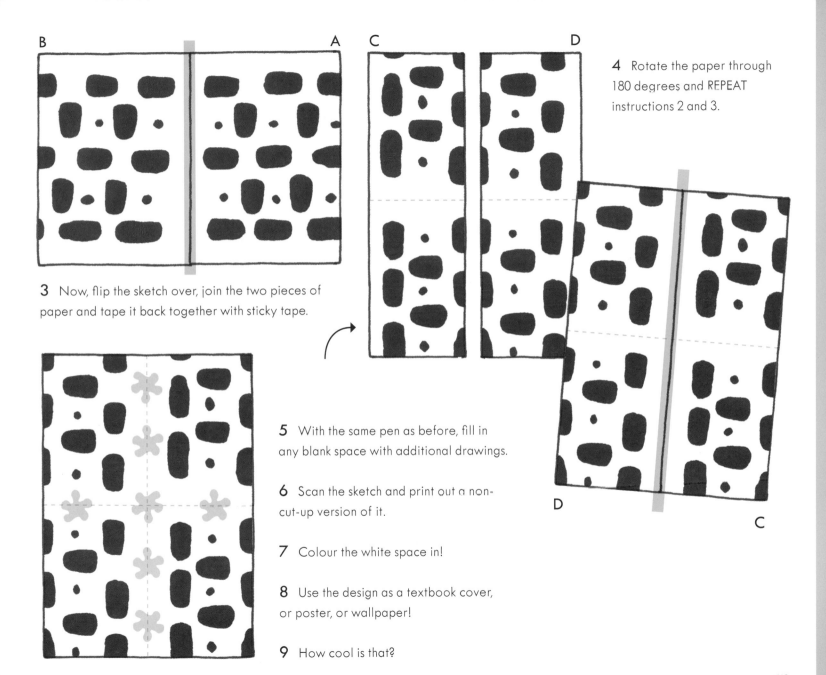

3 Now, flip the sketch over, join the two pieces of paper and tape it back together with sticky tape.

4 Rotate the paper through 180 degrees and REPEAT instructions 2 and 3.

5 With the same pen as before, fill in any blank space with additional drawings.

6 Scan the sketch and print out a non-cut-up version of it.

7 Colour the white space in!

8 Use the design as a textbook cover, or poster, or wallpaper!

9 How cool is that?

D

C

Look Sharp!

SHARPIE PENS

The world's most popular brand of permanent felt-tip pen, the Sharpie, with its extensive range of waterproof colours and nib sizes, is the pen you need when you want to draw big, draw loud and draw outside! Want to find out more about this sharp-looking pen? Then don't worry, you've come to the right page...

Sharpies in Space

It should come as no surprise, given how cool both space and pens are, that Sharpies are the pen of choice for astronauts floating over 400km (250 miles) above Earth onboard the International Space Station. In space, where there is zero gravity, it means that several of the other types of pen, which rely on gravity to 'push' ink downwards, simply wouldn't be able to do their job. Sharpies, however, work by capillary action, so function in zero gravity. 'You can hold a Sharpie any which way and it still works,' said astronaut Chris Hadfield, who commanded the International Space Station in 2012–13.

Write on Water With a Sharpie

Writing on water with a Sharpie is simple — if you have lots of time!

With your Sharpie, simply write your name on a piece of clingfilm attached tightly to a glass slide. Dip the glass slide in a glass of water — VERY, VERY SLOWLY. Your name will appear on the water's surface. Ta-dah! Can you work out why this works?

WRITE A SHARPIE POEM!

Pick up a newspaper and your Sharpie. Choose a news article — any one will do. Write a poem. You can do this by blocking out words, or whole sentences, with your Sharpie pen, leaving behind the words that you want to use in your poem. Make sure you've finished your poem by the end of the article!

SUPER Sharpie

Sharpie MAGNUM PERMANENT MARKER

SUPER Sharpie TWIN TIP

Sharpie FINE POINT

SUPER

KNOW THY SHARPIE

1 The Sharpie Fine Point black felt-tip pen was first introduced in 1964 by the Sanford Ink Company, based in the USA.

2 More than 400 million Sharpies are made and sold each year.

3 Sharpies will write on any surface!

4 The black ink in Sharpies is permanent ink, made with ethylene glycol monobutyl ether (EGBE) in an alcohol solvent.

5 The most common and popular Sharpie is the Fine tip. Other tips include Ultra Fine Point, Extra Fine Point, Brush Tip, Chisel Tip and Retractable Tip.

Think About Ink!

We're all guilty of taking ink for granted. Without ink, our pens are void of employment. For several millennia, ink was the only efficient way to communicate the written word, leaving a record for future generations. Without ink, we would have no history. With the invention of computers and the digital age, less ink is being used, so before its time runs out, let's raise our pens in awe and toast ink! Cheers!

Ink is all about expressing your thoughts. Here's what some famous writers and artists have had to say about ink...

'A drop of ink may make a million think.'

Lord Byron

The word 'ink' comes from the Ancient Greek enkauston, meaning purple or red ink.

'I love the smell of book ink in the morning.'

Umberto Eco

'Never pick a fight with people who buy ink by the barrel.'

Mark Twain

'What joy there is in hearing yourself think, and to make that thinking into ink.'

John Olsen

'I dip my pen in the blackest ink, because I'm not afraid of falling into my inkpot.'

Ralph Waldo Emerson

'Ink is the transcript of thought.'

Alphonse de Lamartine

'The purpose of literature is to turn blood into ink.'

T.S. Eliot

'The strongest memory is not as strong as the weakest ink.'

Confucius

It was the Ancient Chinese who invented ink, more than 5,000 years ago. They concocted a method of making the ink by grinding a mixture of glue (from the hides of animals), carbon black and bones with a pestle and mortar until it was dry. It would then be mixed with water to create an ink paste.

'Pencil in your plans but write your visions in ink.'

Andy Stanley

Iron gall ink was the type of ink Leonardo da Vinci used in his world-famous sketches.

Choose Your Ink

Before an artist begins any artwork, they must first choose their medium. For draughtsmen, and pen-and-ink artists, the type of ink chosen will have a direct result on the final look and feel of a drawing. Thankfully, there are really only two different types of ink to choose from: dye and pigment ink.

Pigment ink, such as India ink (see page 38), is the oldest kind of ink in the world. It works by sticking to the paper.

Dye ink, used in fountain pens, works by becoming absorbed into the fibres of the paper.

Ink Without Trace

USING TRACING PAPER

Using tracing paper is a great way to mix up your drawing with real life, as well as improve your drawing technique. All you need is an idea…and some tracing paper!

Here's a great way to use tracing paper to its full potential by bringing together two different images.

1 First, take a photograph or a tearsheet from a magazine of something you want to draw. Here we are going to draw a bag. It's important to pick a photo that is well lit so that you can see all the details of your subject — you won't be able to see them through the tracing paper if the photo is too dark.

2 Now lay a sheet of tracing paper over the photo and draw in the outline of the bag.

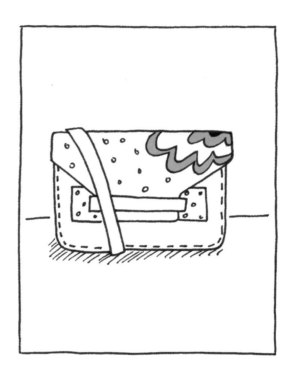

3 The next step is to draw in the details of the bag — pockets, buckles and stitches.

4 Finally remove the tracing paper from the photograph and you will have a basic drawing. Now you have the basics blocked in, you can look at the photo for reference and add any tone and shade and any finishing details.

Meet Honoré de Balzac!

Armed with only his goose-quill pen and his beautifully decorated walking stick, Honoré de Balzac conjured words that changed the world. Often regarded as the first writer to introduce realism into novels, it was Balzac who used his fiction to convey a sense of everyday life in France in the 19th century. As such, he is now remembered as 'the Shakespeare of the novel'.

'I am a galley slave to pen and ink.'
Honoré de Balzac

WRITE LIKE BALZAC

1 Balzac was a disappointment to his parents, after he refused to enter the legal profession. His father gave him pocket money on the understanding that at the end of two years he should produce a masterpiece or else abandon his ambitions.

2 Balzac reportedly died of caffeine poisoning — he supposedly drank 50 cups a day!

3 Written in 1819, *Cromwell*, Balzac's first play, was a failure. As a result, Balzac began using *noms de plume* instead of his real name.

4 *The Human Comedy* (*La Comédie Humaine*) is Balzac's most famous novel. Over a series of lengthy volumes, it depicts the details of French life after the fall of Emperor Napoleon Bonaparte.

5 Balzac famously kept a notepad by his bed so that should he awake from a dream, or nightmare, with an idea in his head he could write it down immediately. But, should you want to be as prolific as Balzac, who wrote 85 novels in 20 years, the trick is to wake up early. This has recently been verified by science! Every night, Balzac would wake up at 1am, after seven hours of sleep, and write until he went to bed in the late afternoon.

Take a Refreshing Dip

THE GLASS DIP PEN

From mirrors to windows, spectacles to screen, microscopes to telescopes, we all know that glass is one of humankind's most beloved inventions. We use it every day in almost everything we do. However, glass isn't just good for watching yourself or the stars, it also makes for a wonderful writing instrument, in the slender, multi-coloured shape of a glass dip pen.

Go Glass Go!

Glassmaking came to Britain with the arrival of the Romans 2,000 years ago. The Romans kept their glass skills to themselves, however, and it was not until their Empire collapsed, around AD450, that their glassmaking majesty was allowed to spread across Europe. Master glass craftsmen on Murano, a tiny island near Venice, Italy, were the first to develop the artistic and technical skills and technology required for glass-blowing. In the process, they produced the world's most prized glass. In the 17th century, Murano glass pens were so beloved they were the must-own writing instruments of the well-to-do.

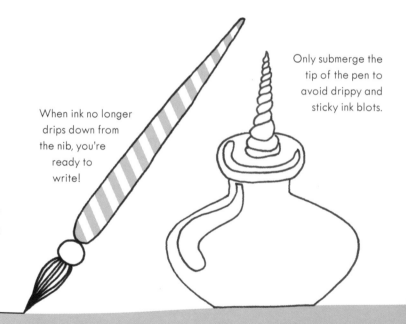

When ink no longer drips down from the nib, you're ready to write!

Only submerge the tip of the pen to avoid drippy and sticky ink blots.

GLASS – BY GEORGE!

When it comes to truly seeing the light, it was George Ravenscroft's work with glass that made the world sit upright. It was he, who in the mid-1600s, created a new type of highly refractive glass that allowed the invention of spectacles, telescope and microscopes.

Glass Pen Exercise

Glass pen tips are very strong, but also very fragile — they are perfect for developing and mastering your line drawings and calligraphy. In honor of the Venetians, let's take your glass pen for a dip in Venice's watery world and a draw the outline of a gondola and gondolier with a colour of your choice. Now, rinse your glass pen with water, refill with another colour, and follow the line of your original drawing very closely underneath. Repeat this process, with many different colours, until the drawing is 'coloured in'. The result will look as beautiful as any Murano glass pen!

BENEFITS OF A GLASS DIP PEN

1 Clean and steady flow.

2 Easy to rinse clean with water; this allows a fast switch between different colours.

3 Writes several sentences before requiring a refreshing dip!

History of Glass

Obsidian, a form of naturally occurring glass, is created when the intense heat of a volcanic eruption melts sand and cools to create a hard, highly reflective material. This was the first glass used by man as tips for hunting spears!

Meet Marjane Satrapi!

Graphic novelist, cartoonist, illustrator, film director, children's book author — when it comes to making a point with a brush pen, Marjane Satrapi's era-defining autobiographical comic book *Persepolis* tells us a story like no other in a way never seen before.

SEE THE WORLD THROUGH YOUR EYES

One of the most revered female cartoonists in the world, Satrapi is a role model for aspiring writers and cartoonists. Satrapi's black-and-white character drawings may look simple, but in fact they take hours to perfect. Their simplicity acts as a visual representation of how Marjane saw the world of the Iranian Revolution through the eyes of a child, in a nation where everything was black and white. Satrapi's lines are bold and she does not use techniques like crosshatching, instead using the high contrast of black ink on a white surface to represent emotion and technique. So, let's draw like Marj!

1 Grab your trusty brush pen. It's perfect for this exercise.

2 Now, look at yourself in a mirror. *Draw yourself as a simple cartoon*. Accentuate the features you like or dislike; reduce your complex features to the basic features that you think define YOU. *What do you look like?*

3 Draw three square panels. They don't need to be of equal length or height. Let them represent your emotions. *Are you feeling out of shape?*

4 In these panels, draw three versions of your cartoon-self — one happy, one sad, one angry, leaving room above for a cartoon bubble for text.

5 In each bubble above your cartoon's head, write what makes you happy, sad, and angry in one sentence.

PERSEPOLIS

First published in 2000, *Persepolis* details the autobiographical account of Marjane's childhood and adolescence growing up in Iran following the Revolution and the subsequent war between Iran and Iraq. Whereas other comic books use vivid splashes of primary colours to present technically drawn characters who spout catchphrases and one-liners, Satrapi rejected these techniques for *Persepolis*. Instead she used black, using only her favourite Pentel brush pen, to block colour her simple characters (designed to appeal to and represent everyone) who use direct language to describe their emotions.

'The first writing of the human being was drawing, not writing.'
Marjane Satrapi

Pen Quotes #2

'Do not consider it proof just because it is written in books, for a liar who will deceive with his tongue will not hesitate to do the same with his pen.'

Maimonides

'I wear my pen as others do their sword.'

John Oldham

'There are two powers in the world; one is the sword and the other is the pen. There is a great competition and rivalry between the two.'

Muhammad Ali Jinnah

'Pen, war and parchment govern the world.'

Benjamin Franklin

'People still think of me as a cartoonist, but the only thing I lift a pen or pencil for these days is to sign a contract, a check, or an autograph.'

Walt Disney

'Writing comes from the heart. If we can help the hand to perform the task, what is so wrong with that?'
Laszlo Biro

'I prefer the pen. There is something elemental about the glide and flow of nib and ink on paper.'
James Robertson

'No pen, no ink, no table, no room, no time, no quiet, no inclination.'
James Joyce

'But words are things, and a small drop of ink, Falling like dew, upon a thought, produces That which makes thousands, perhaps millions, think.'
Lord Byron

'A pen is to me as a beak is to a hen.'
J.R.R. Tolkien

'Art thou a pen, whose task shall be
To drown in ink
What writers think?
Oh, wisely write,
That pages white
Be not the worse for ink and thee.'

Ethel Lynn Beers